MITSUAKI IWAGO'S
PENGUINS

CHRONICLE BOOKS
SAN FRANCISCO

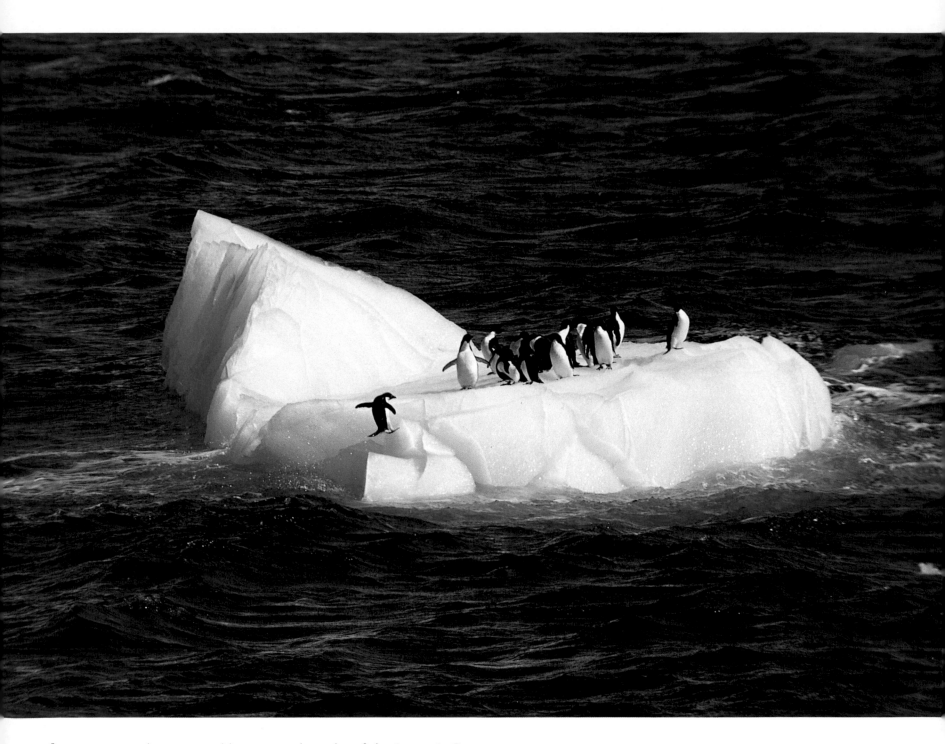

As warm water changes to cold, we enter the realm of the Antarctic Ocean.

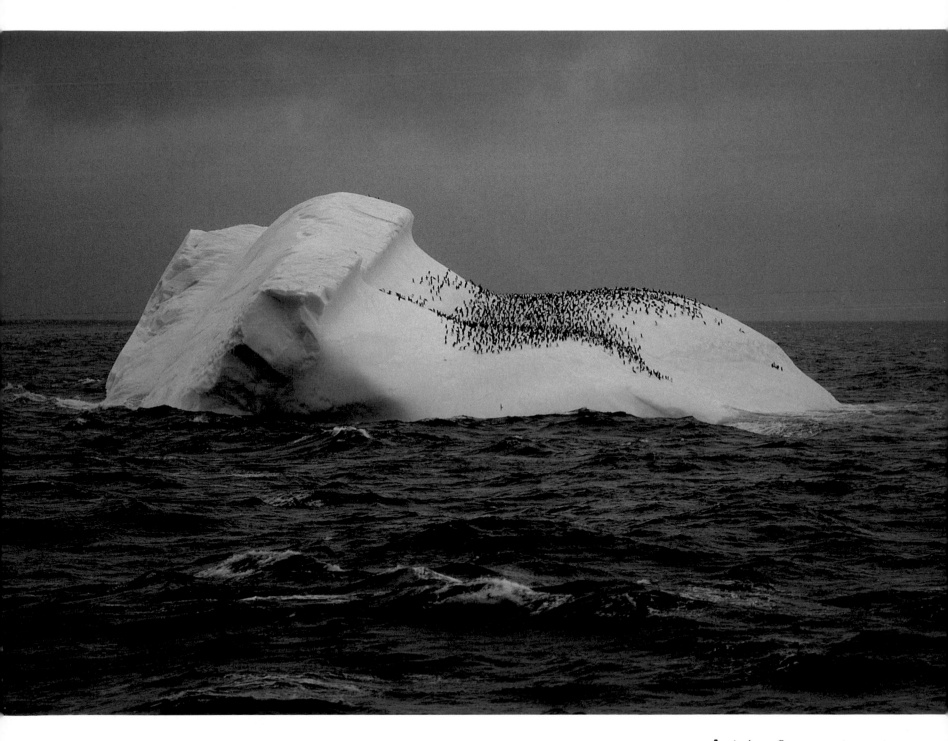

An iceberg floats near Antarctica.

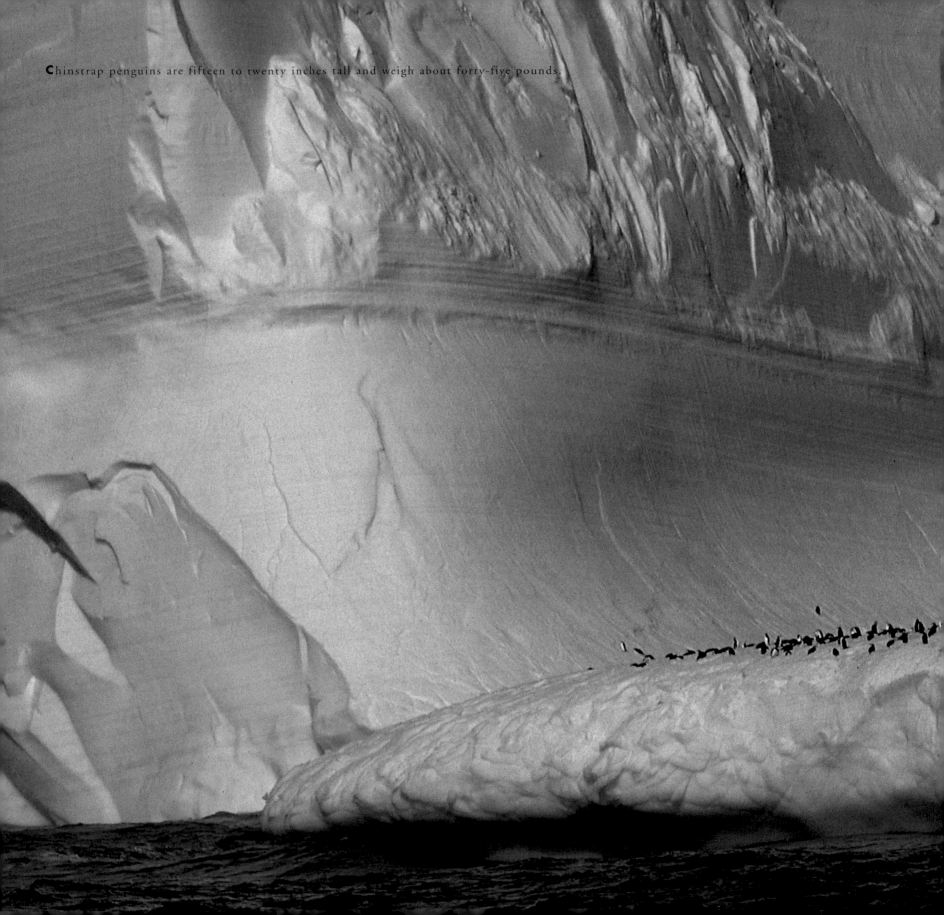

Chinstrap penguins are fifteen to twenty inches tall and weigh about forty-five pounds.

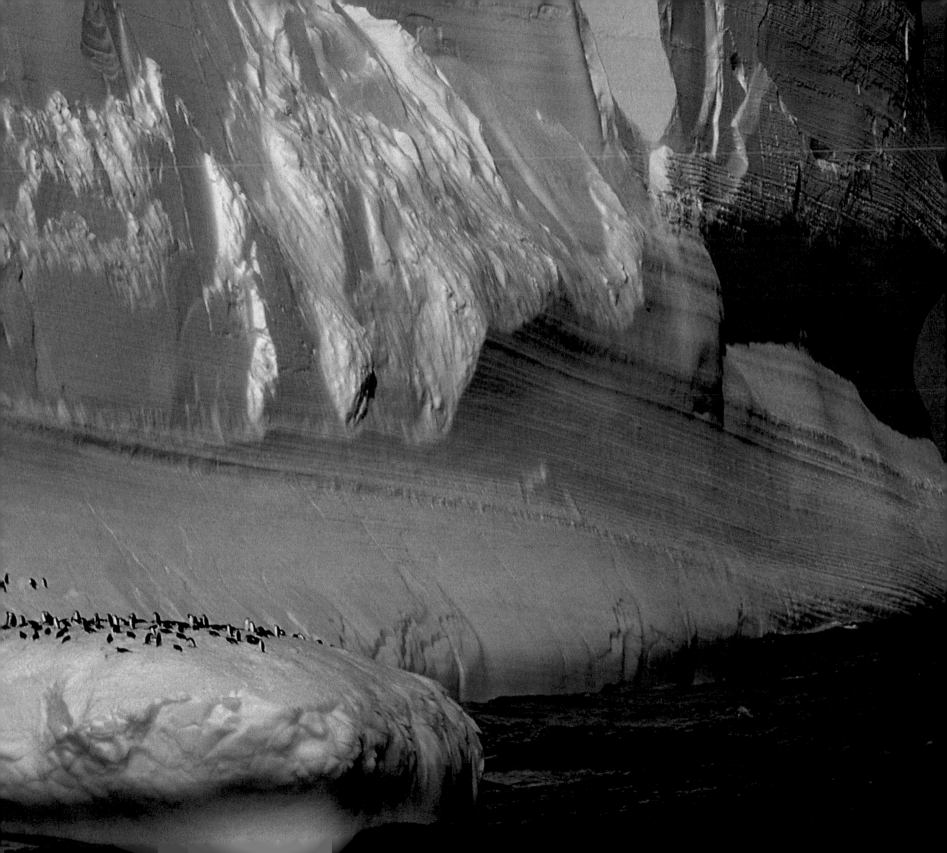

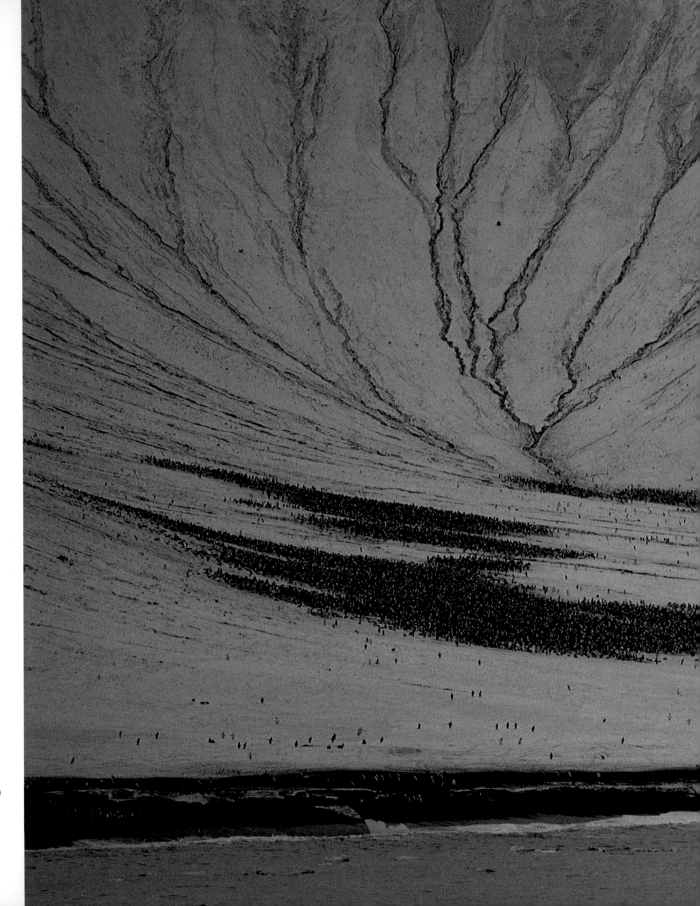

Penguin rookeries (nesting areas)
are near the ocean.

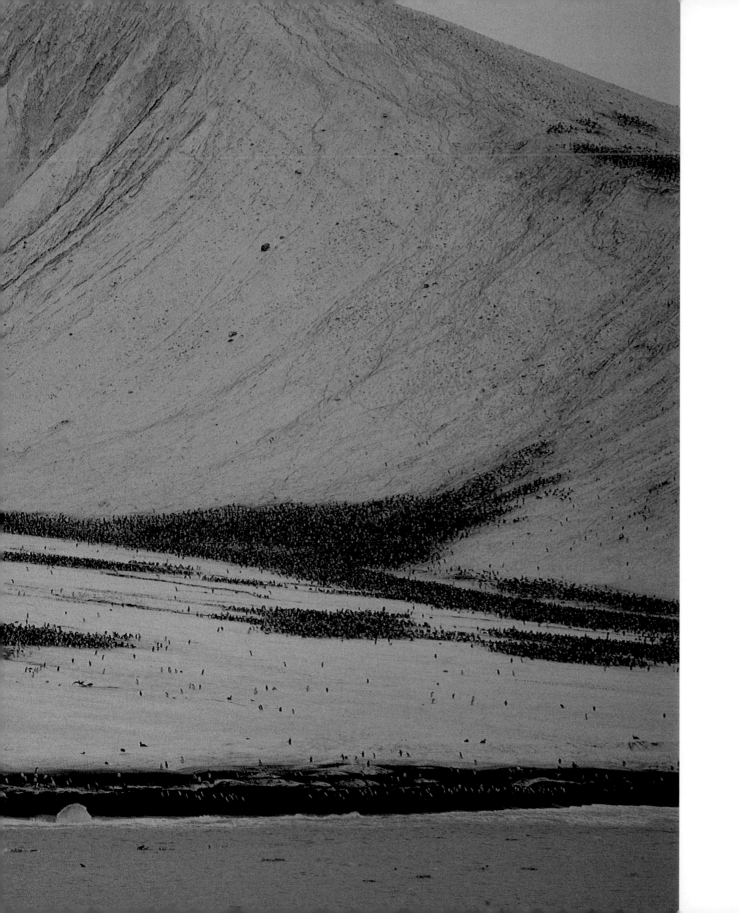

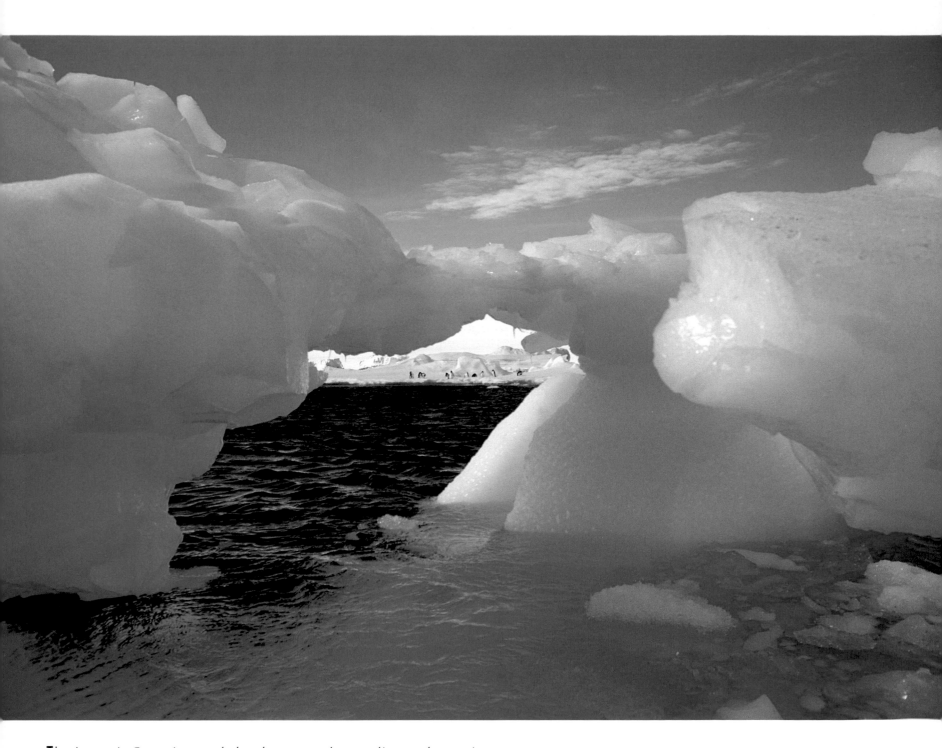

The Antarctic Ocean is crystal clear because no humans live on the continent.

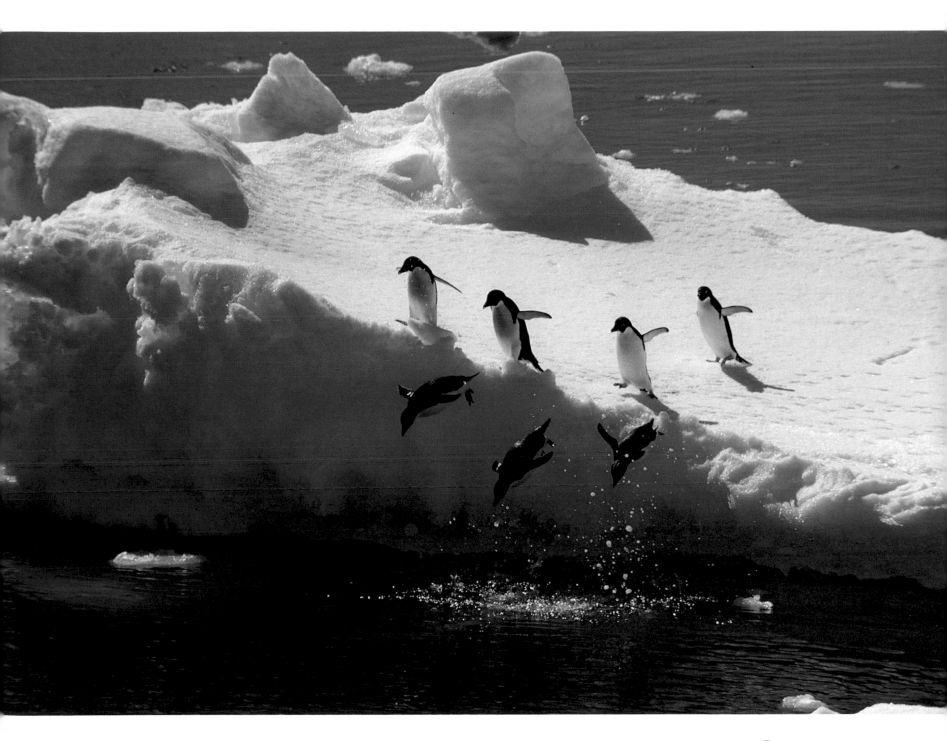

Penguins live in the sea.

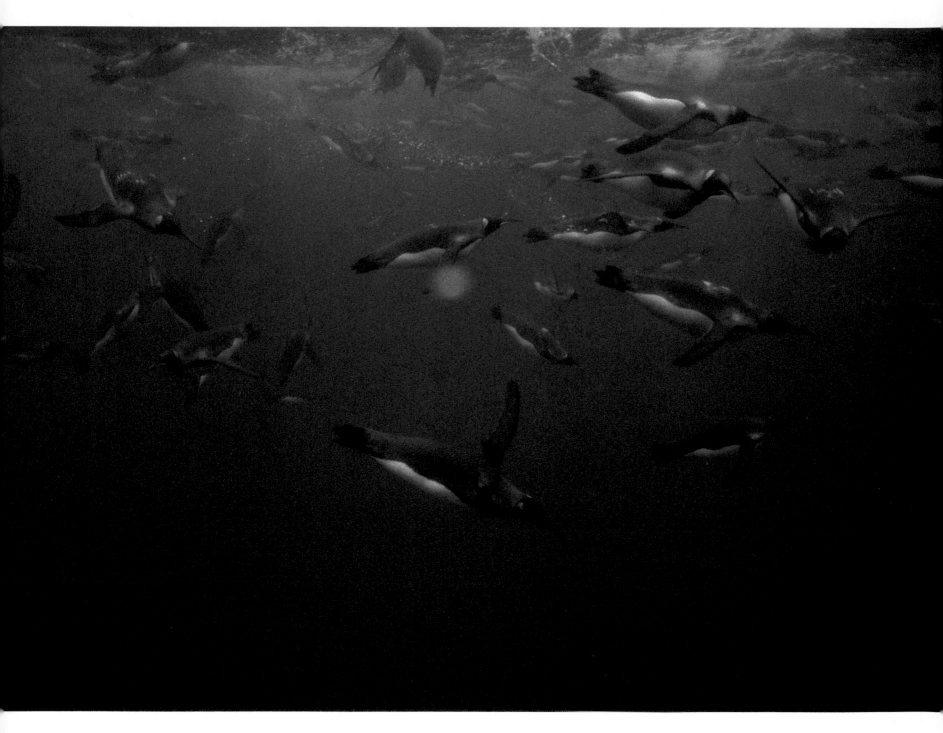

King penguins use their wings beneath the sea.

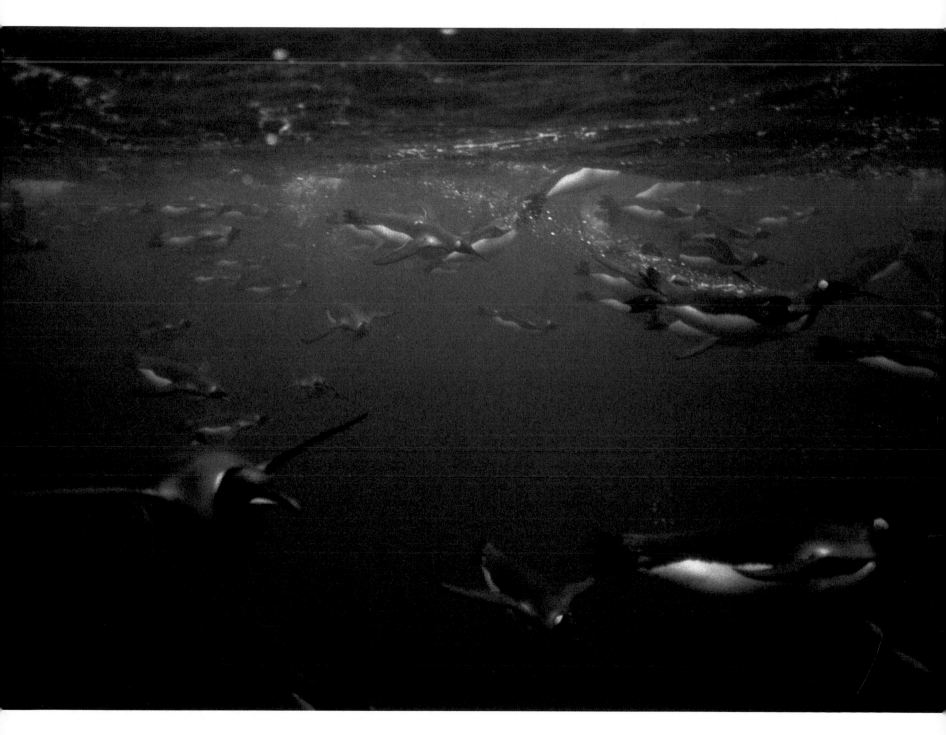

They swim fast—about twenty miles an hour.

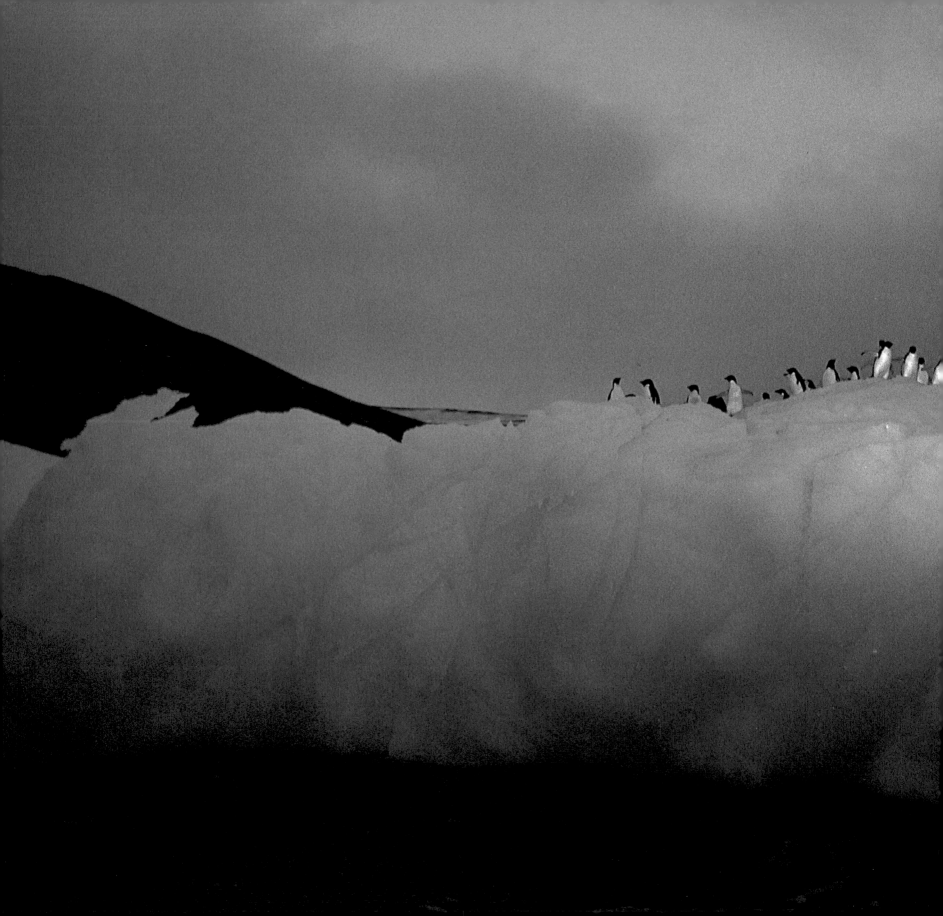

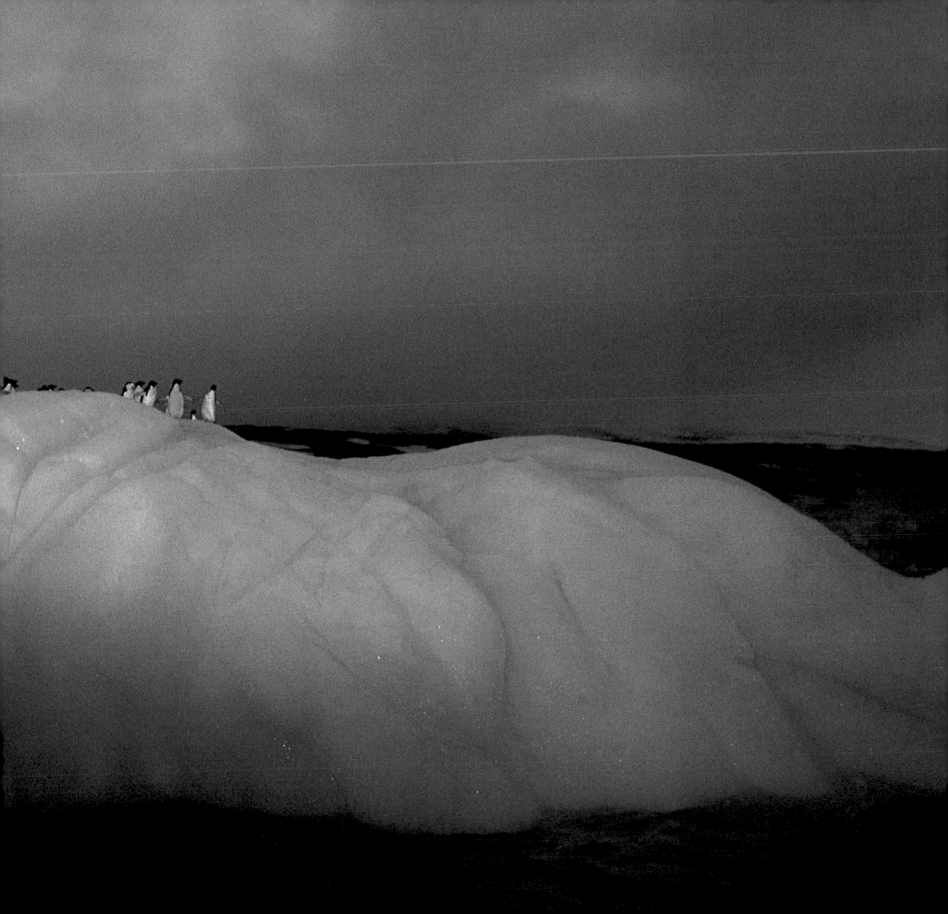

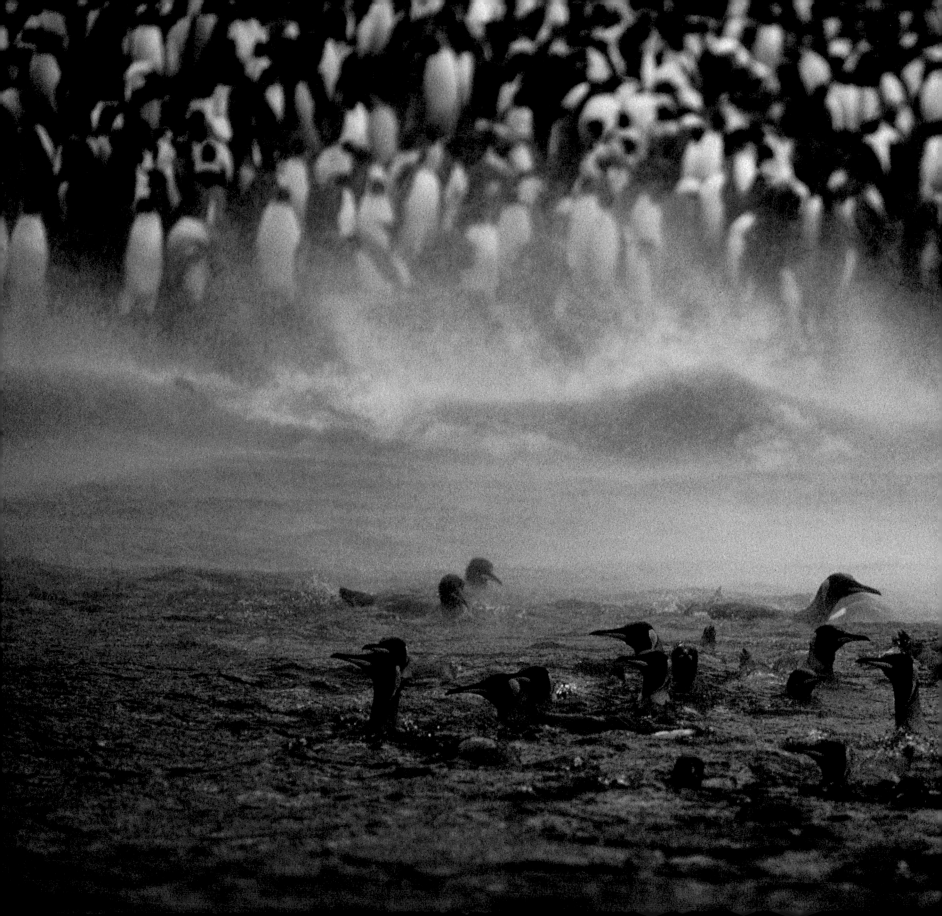

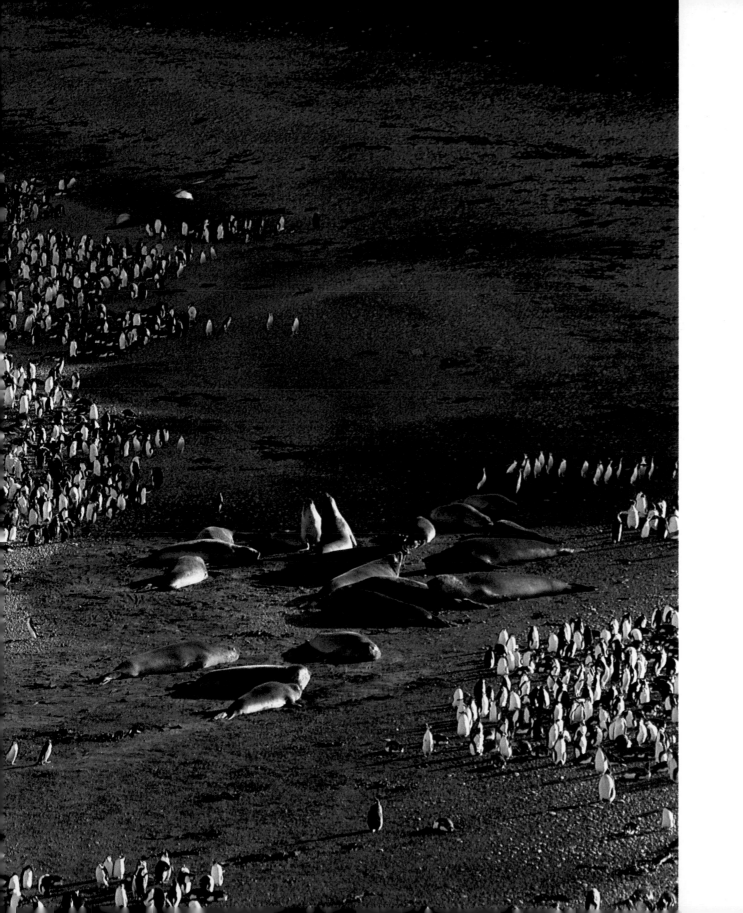

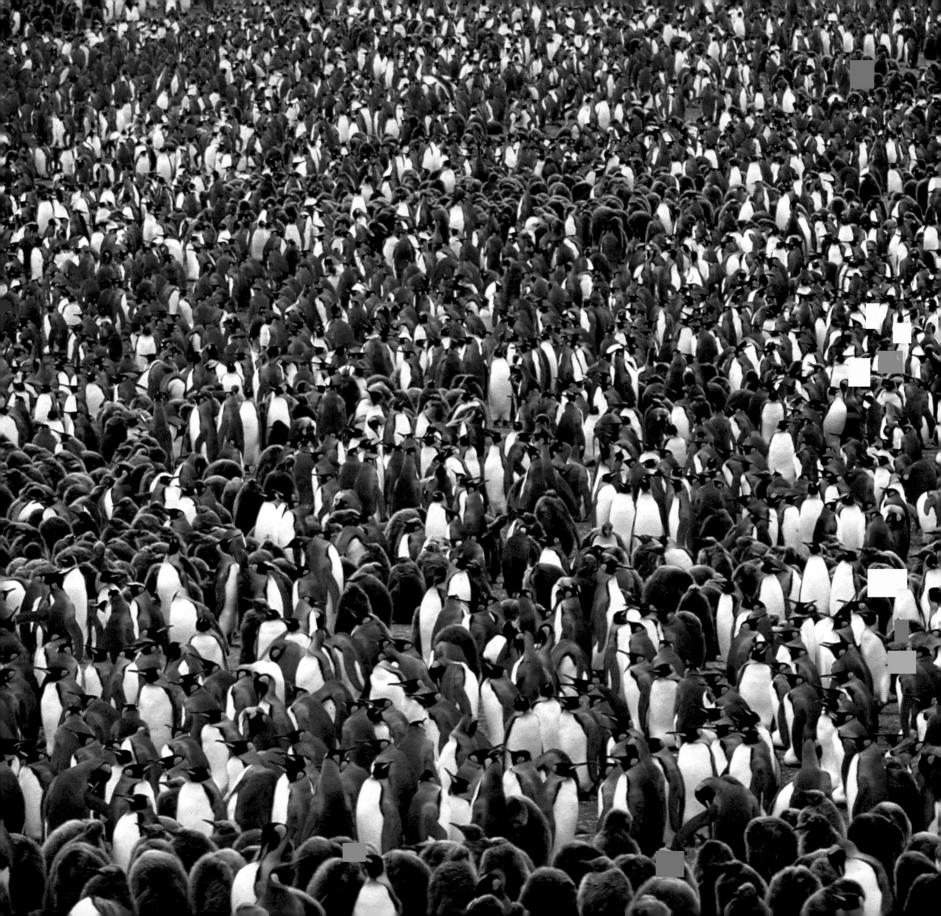

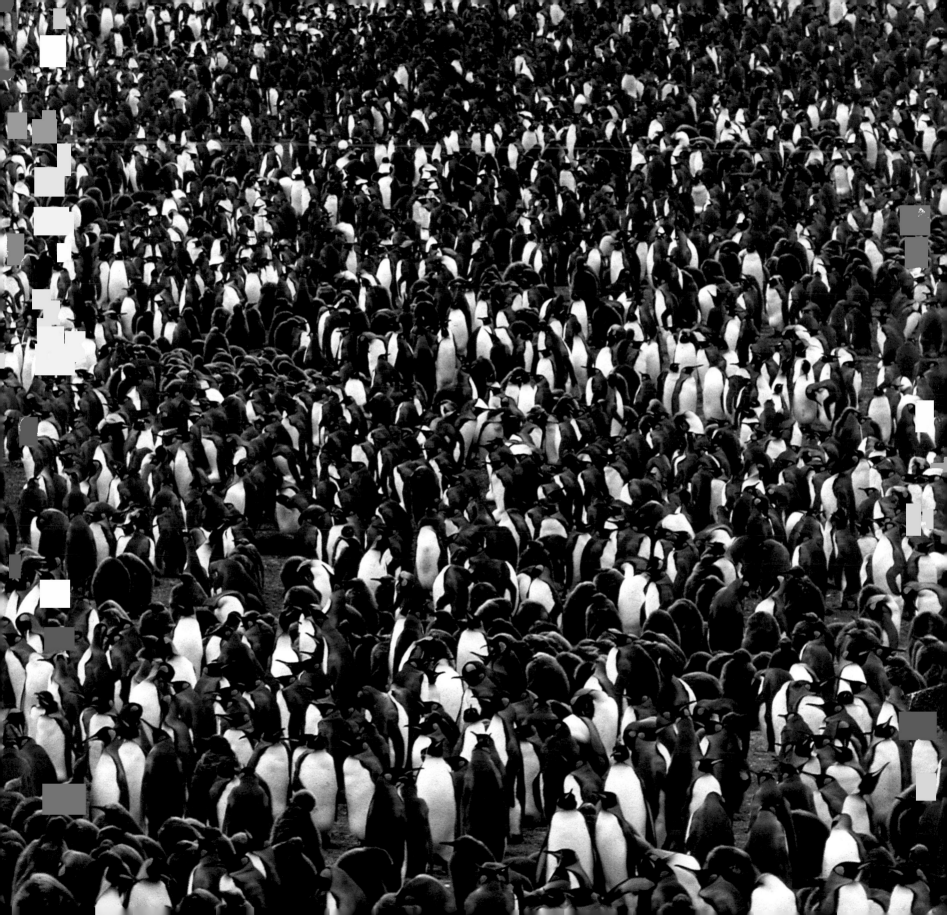

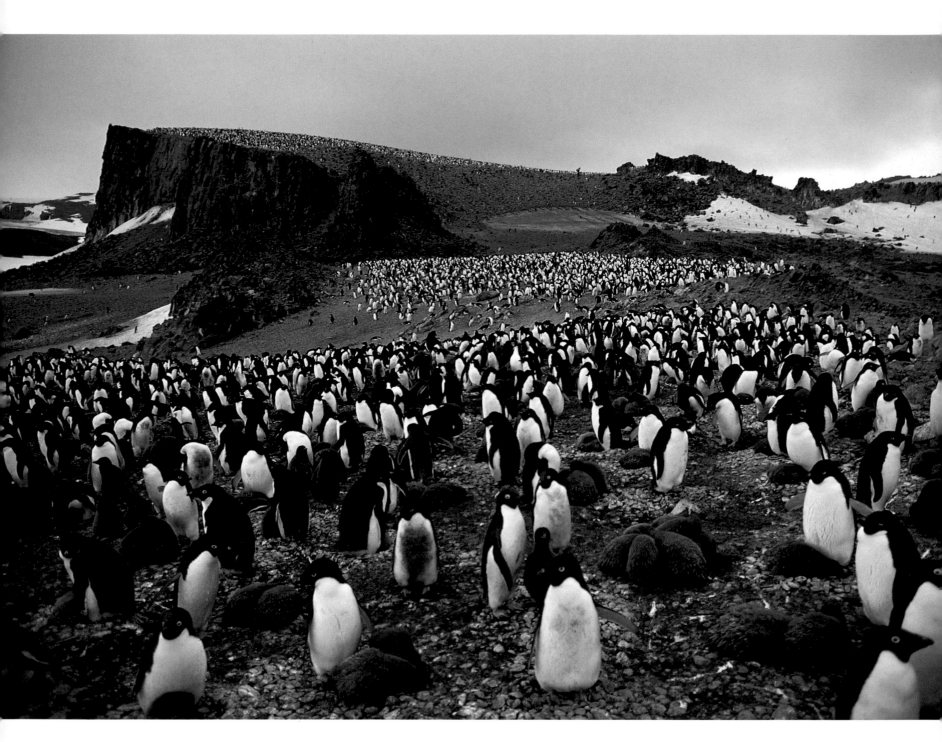

An Adélie penguin rookery. The fluffy-feathered penguins are the juveniles.

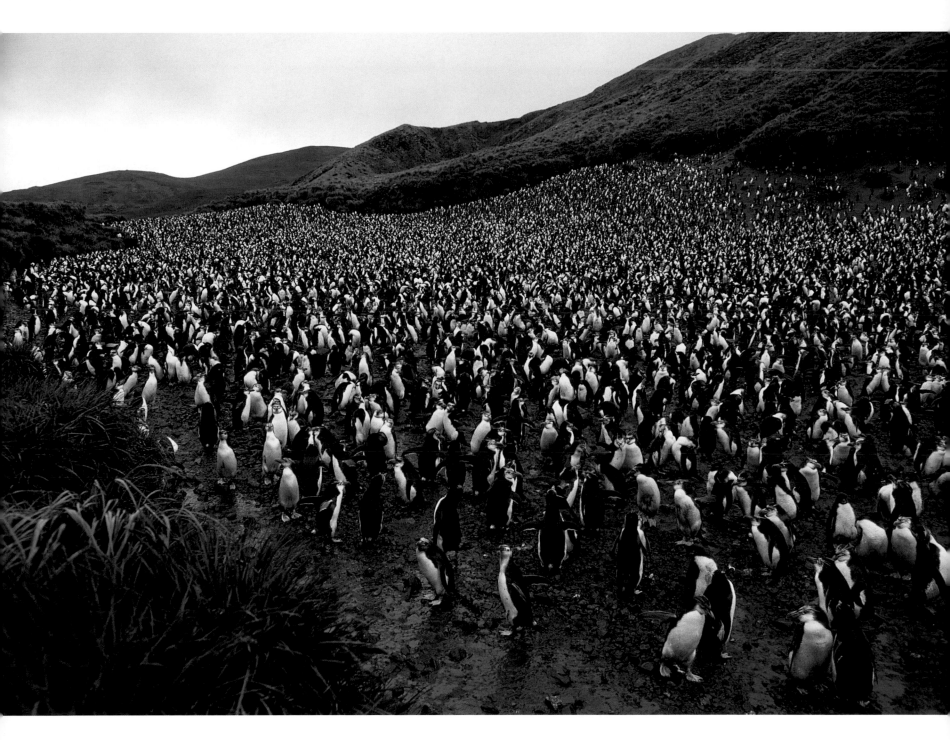

Territory for a penguin consists of the area within reach of its beak.

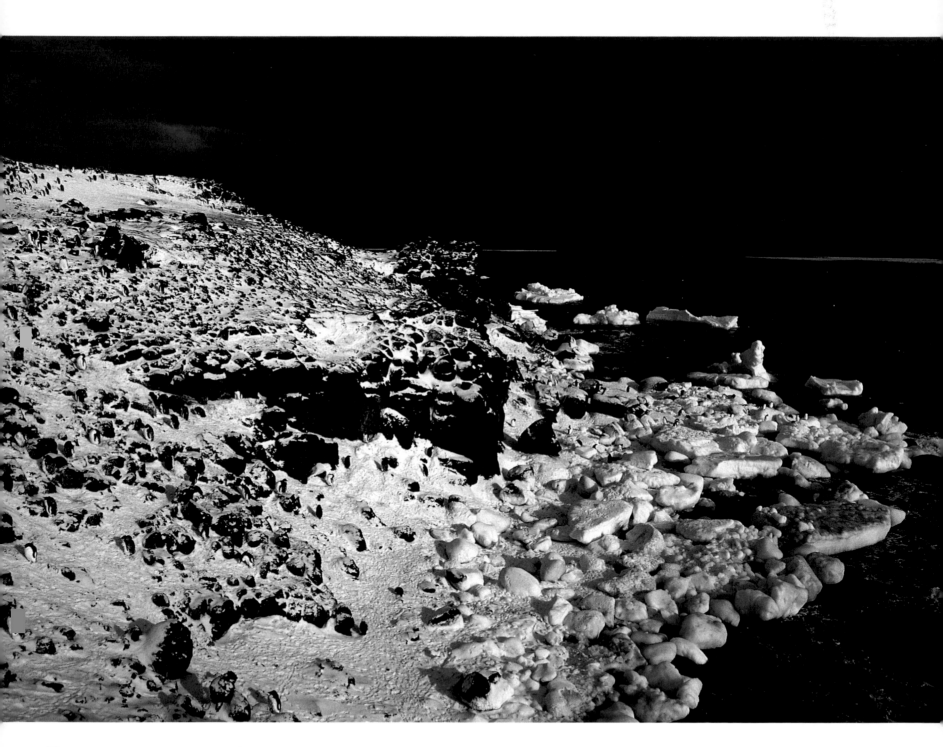

The colors of the penguin are white and black; so are the colors of Antarctica.

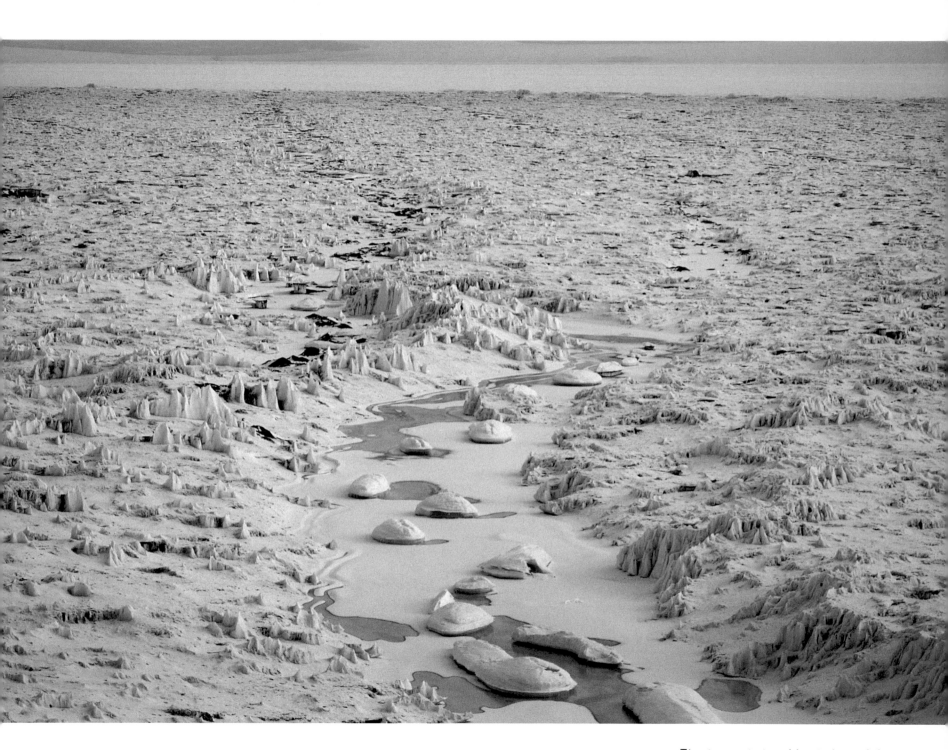

The Antarctic is cold, windy, and dry.

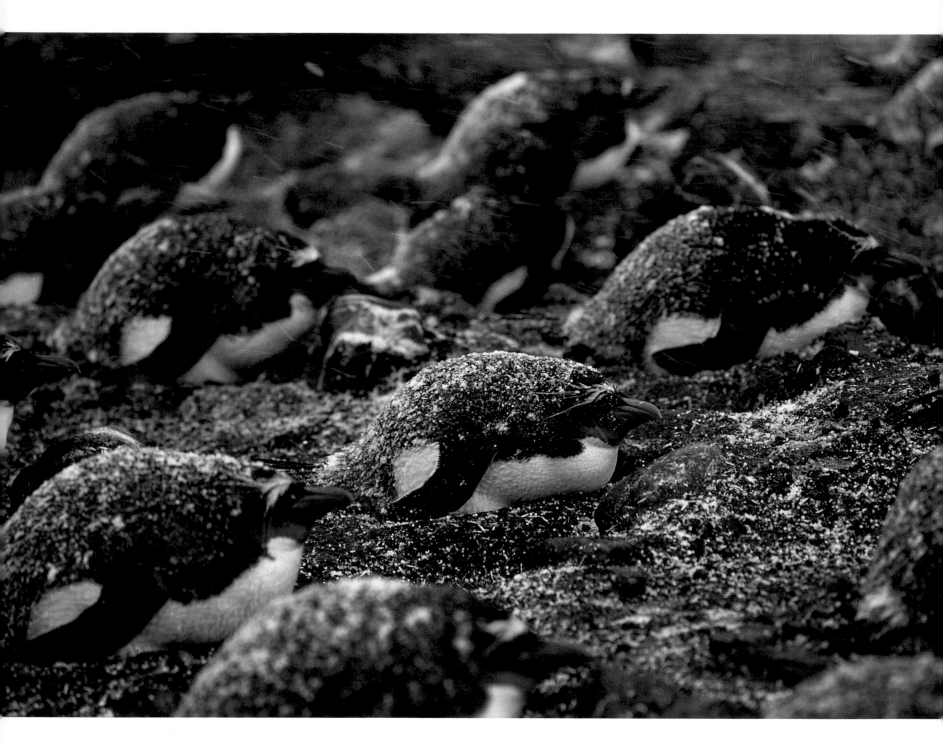

Macaroni penguins warm their eggs and chicks.

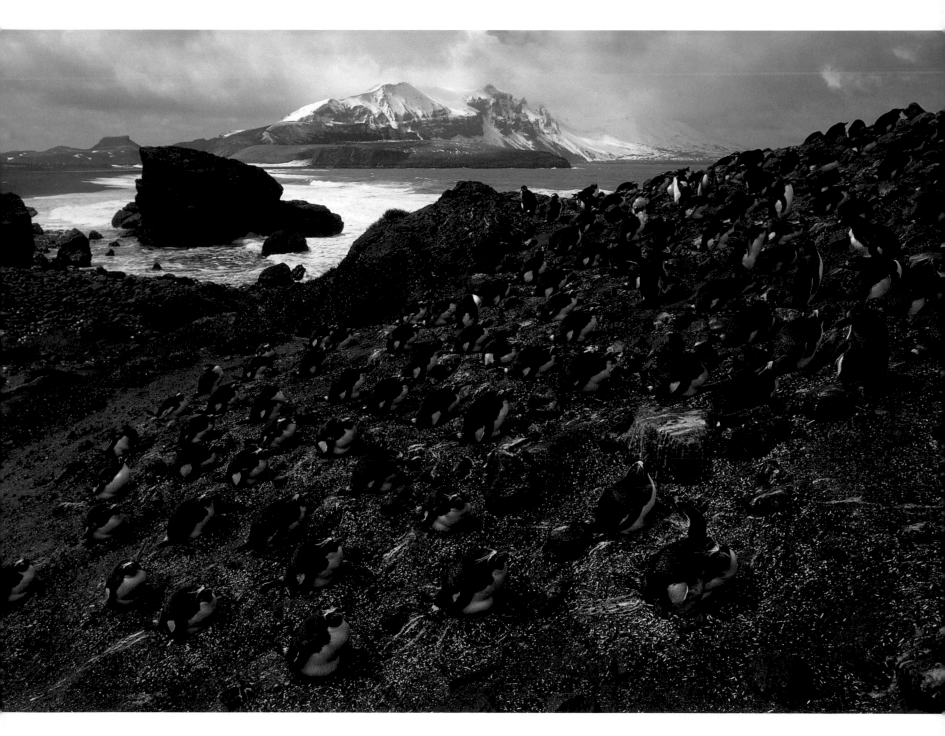

Their yellow crest feathers make them look like stylish gentlemen.

Black clouds bring white blizzards.

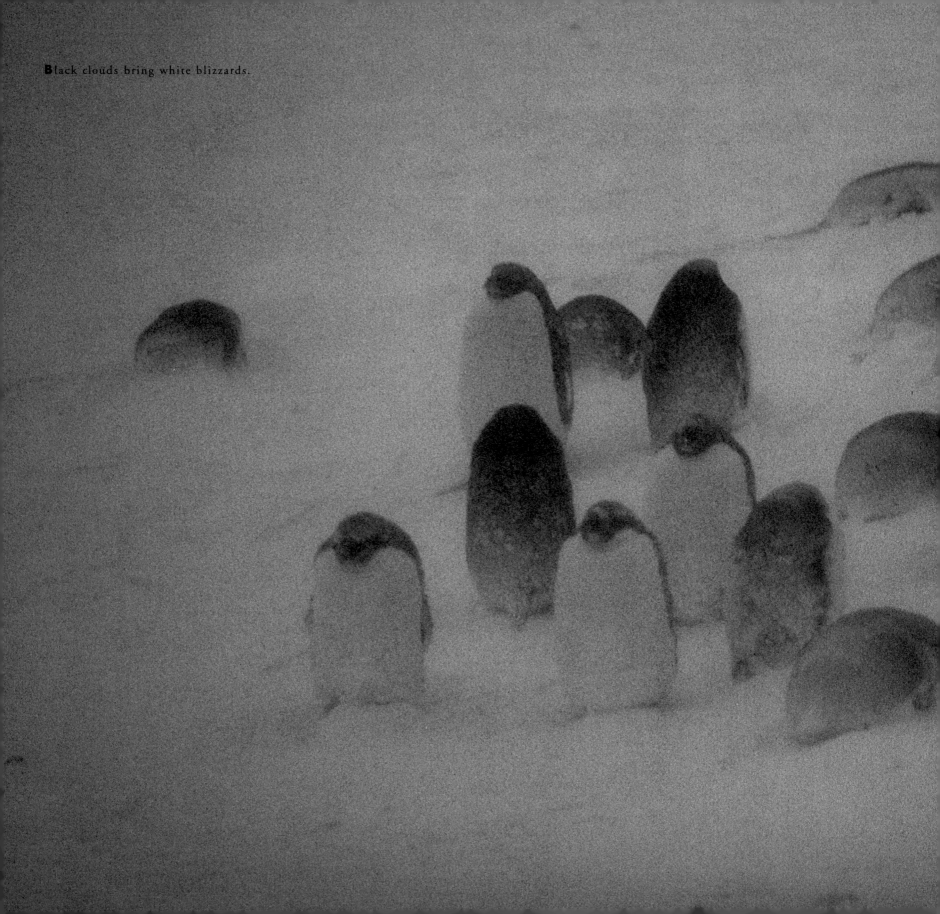

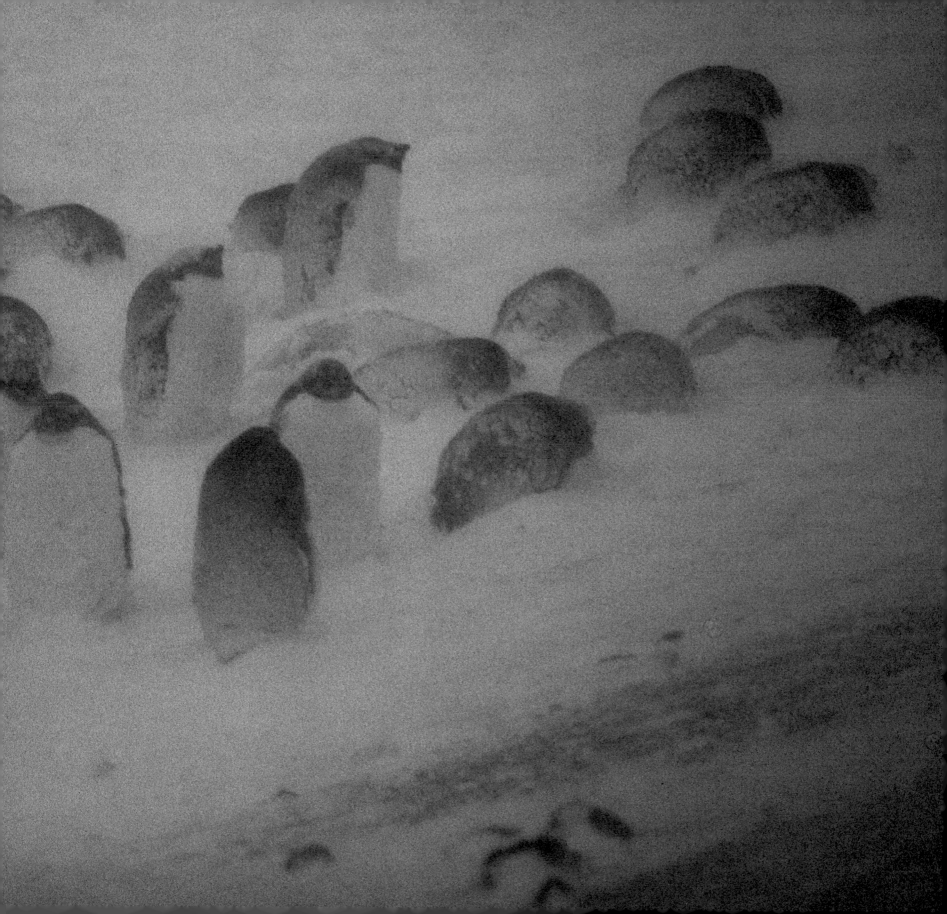

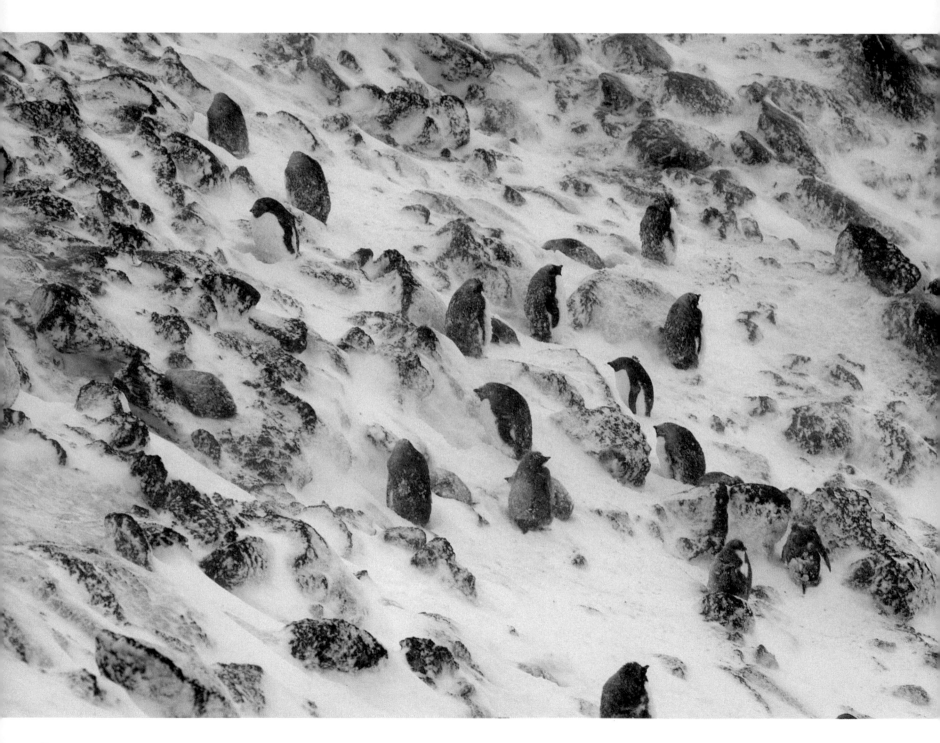

Blizzards can last for several days.

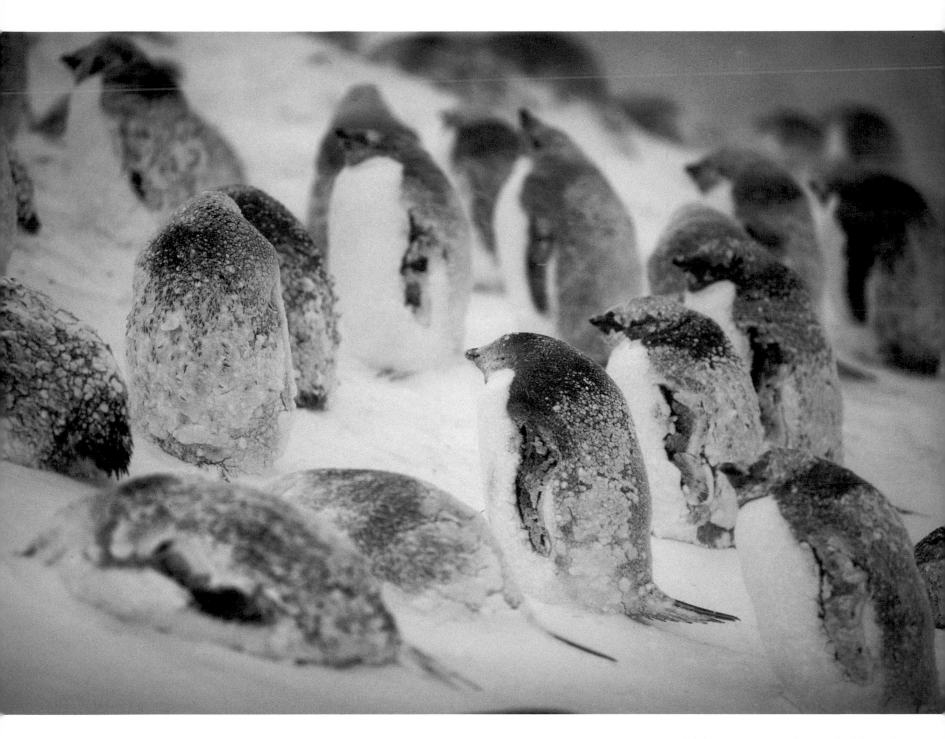

Adélie penguins enduring the blizzard.

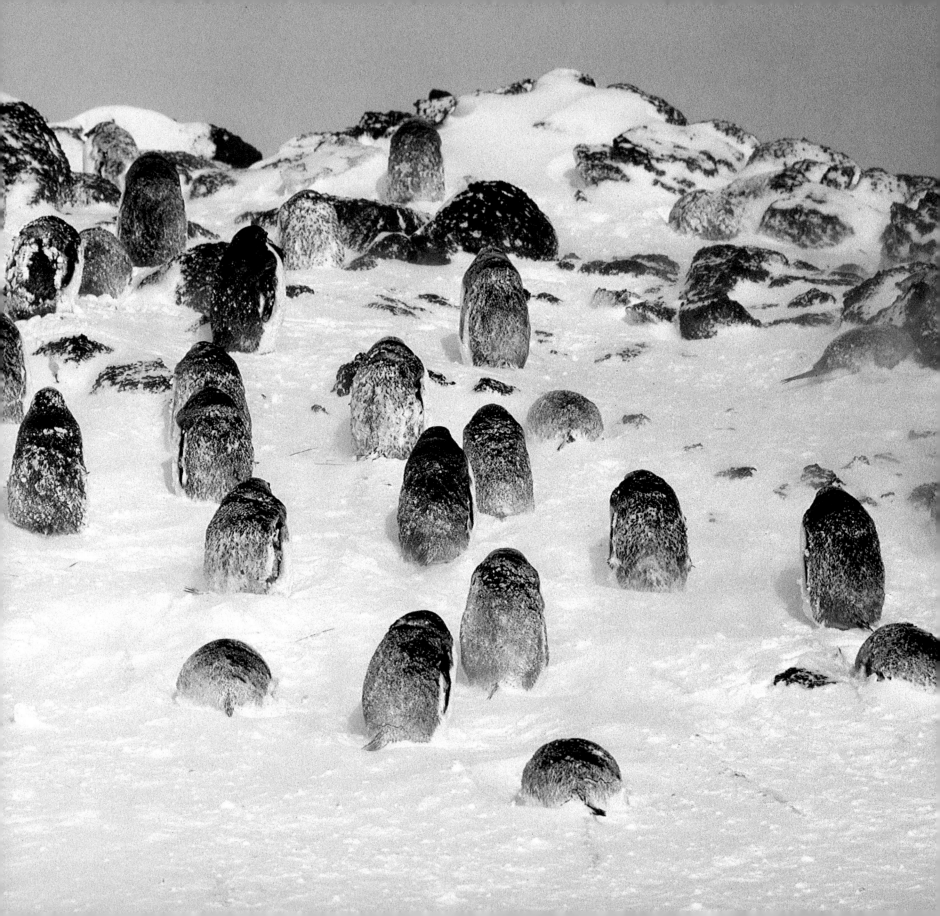

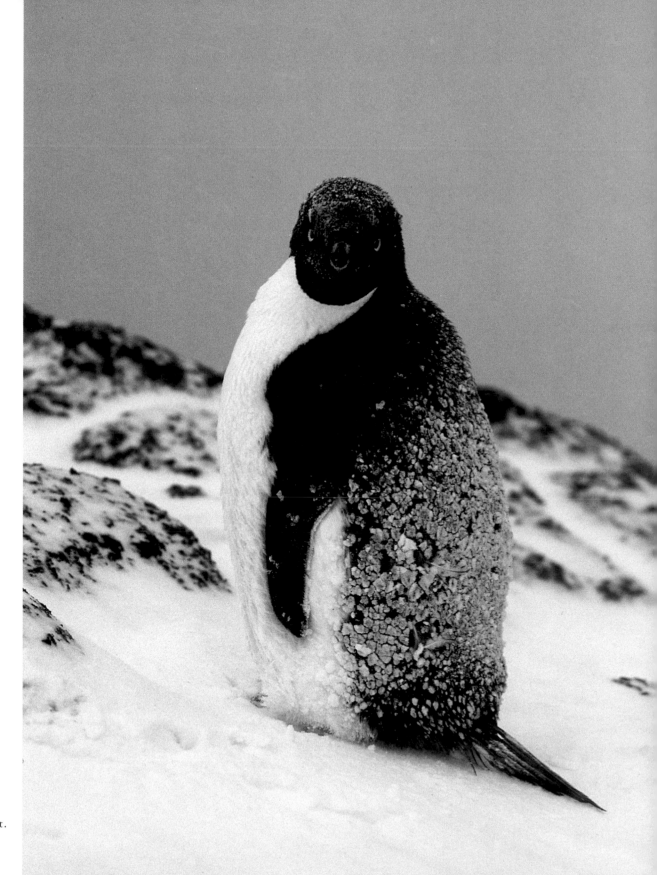

Things begin to brighten up just a bit.

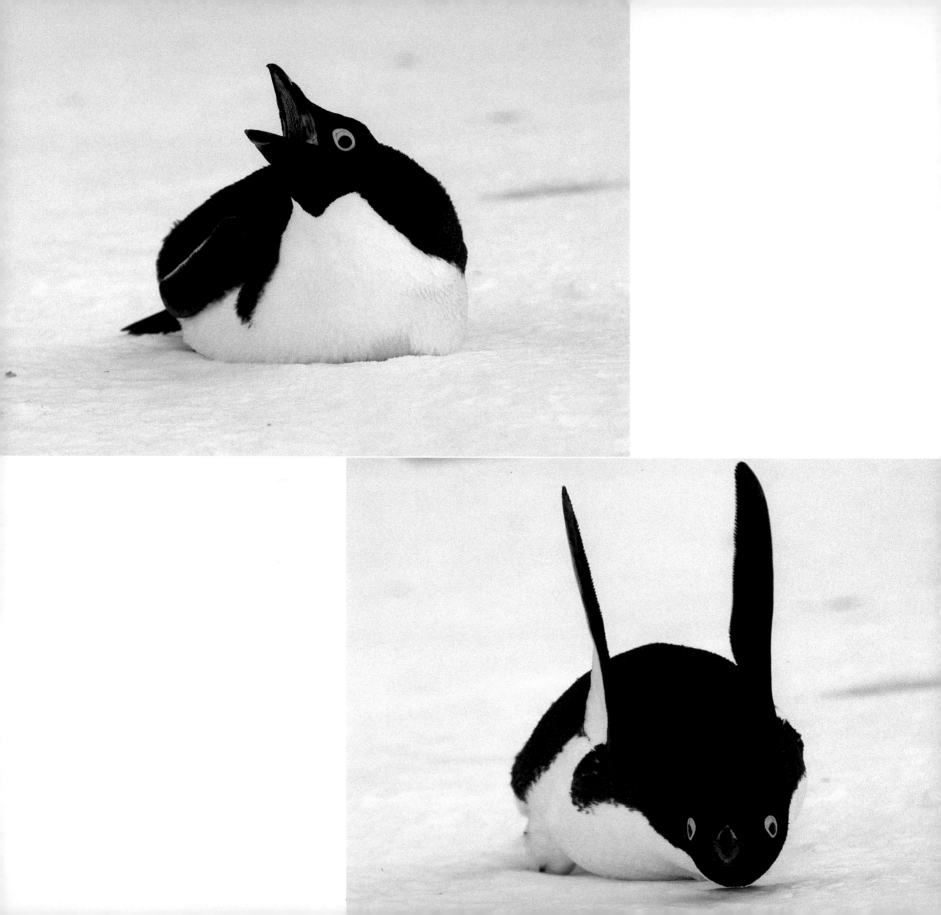

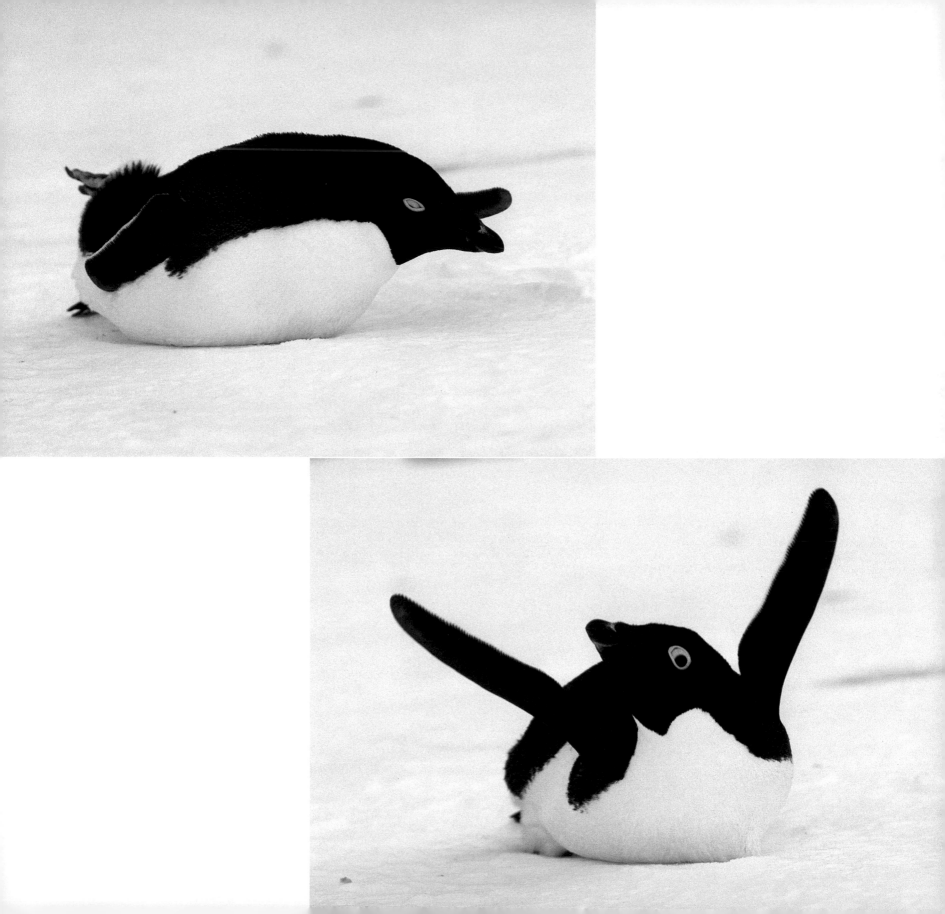

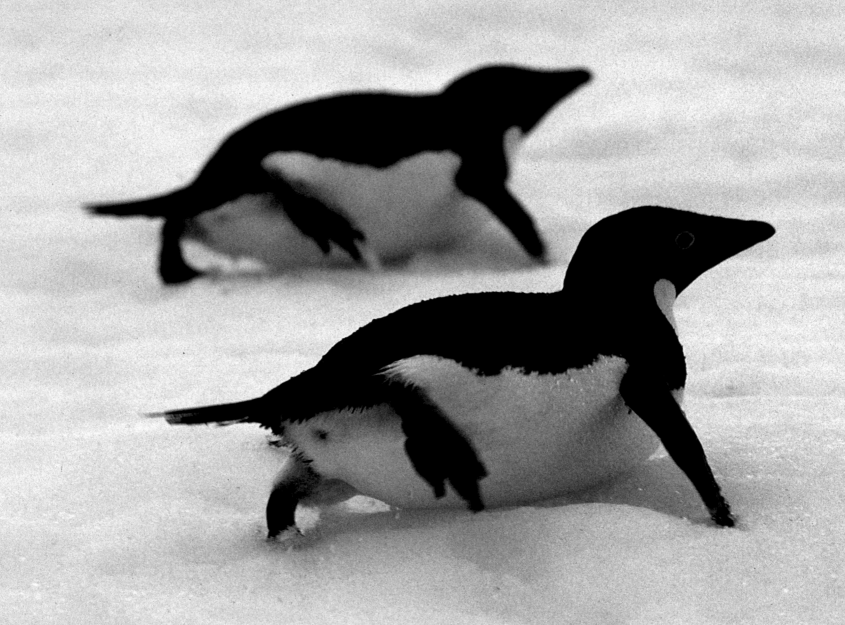

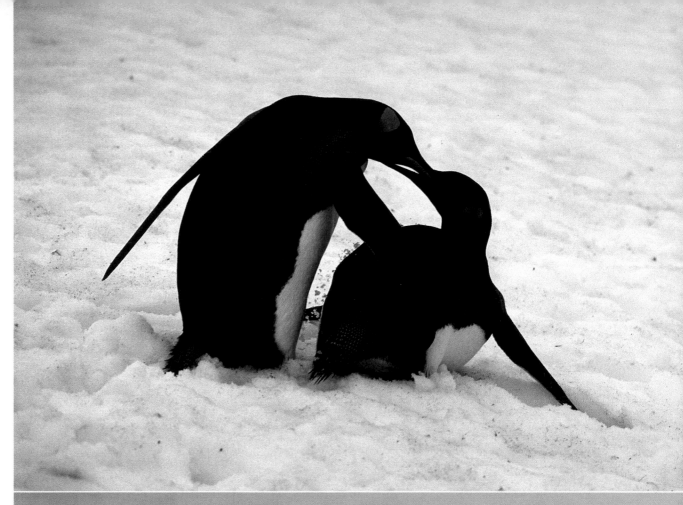

(left)

It is faster for penguins to glide
on their bellies than to walk.

King penguins (*top*) and chinstrap
penguins (*below*) fight by pecking
each other with their beaks and
crying out sharply.

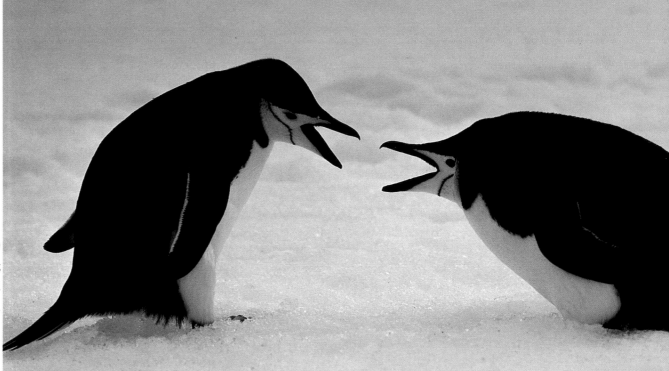

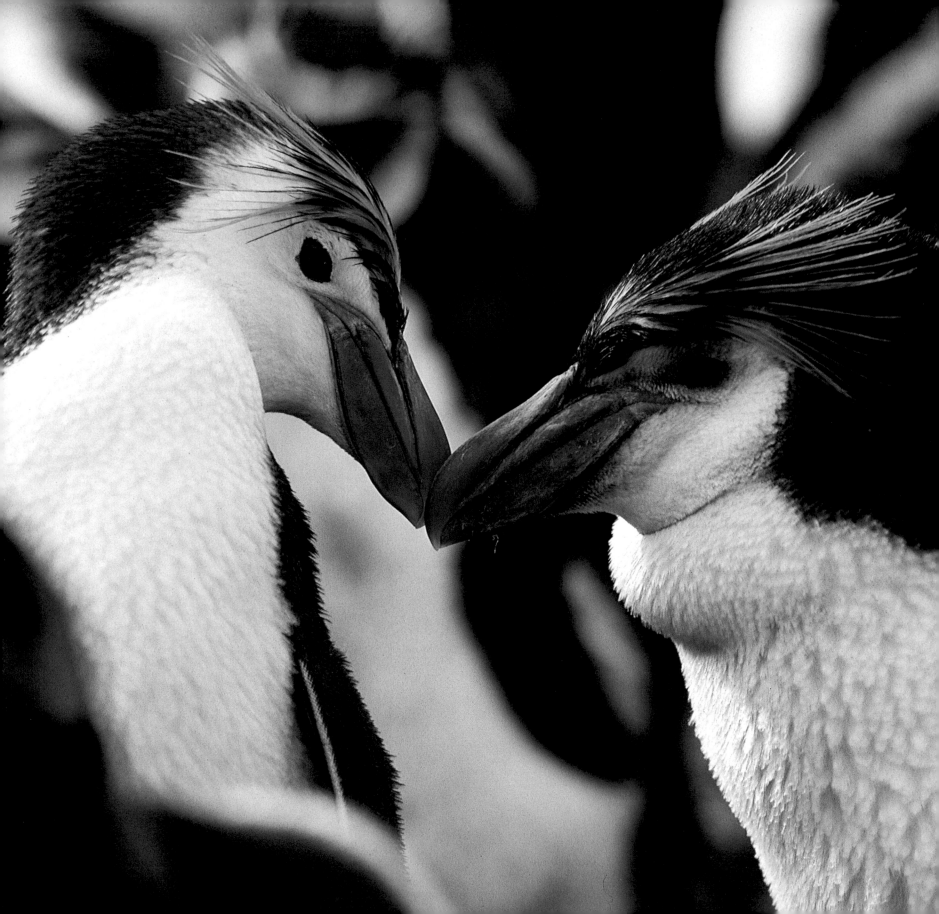

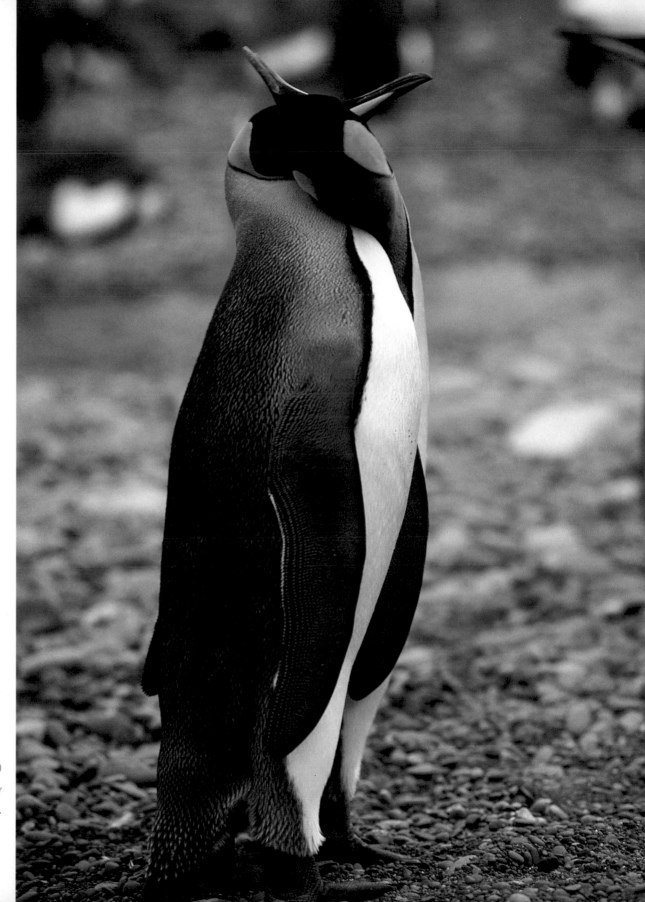

(*left*)

Male and female royal penguins
groom their feathers.

(*right*)

When king penguins stretch, they
seem to grow another ten inches.

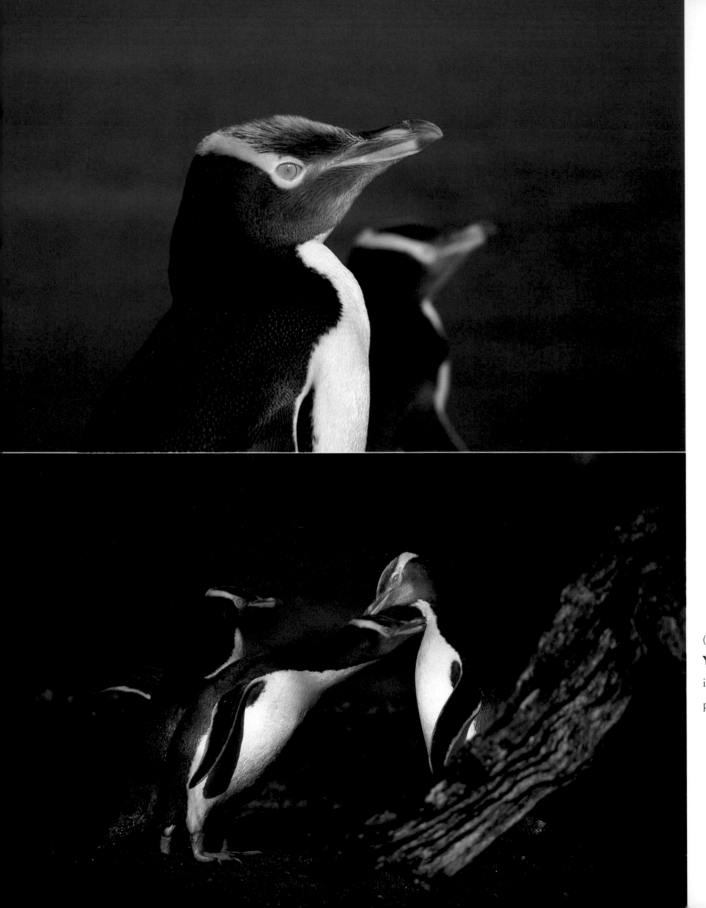

(*left*)

Yellow-eyed penguins. Though
it is not known why, their
population is on the decline.

(*right*)

Adélie penguins mating.
Their breeding period is from
December to February.

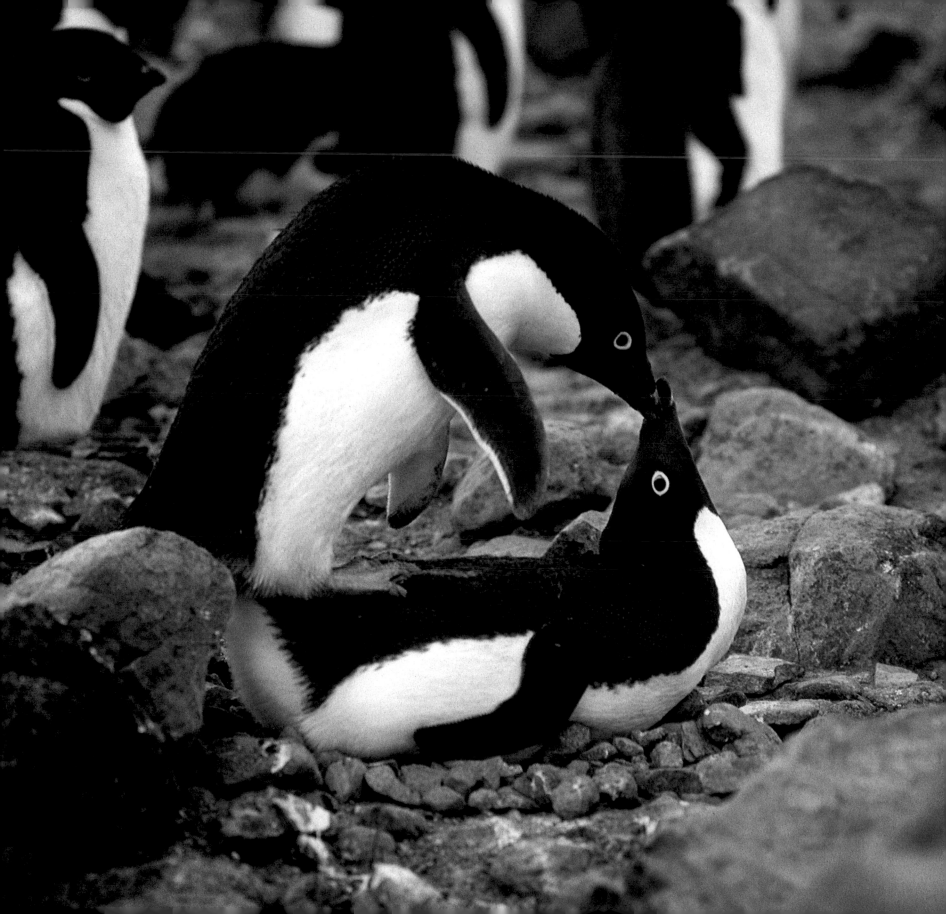

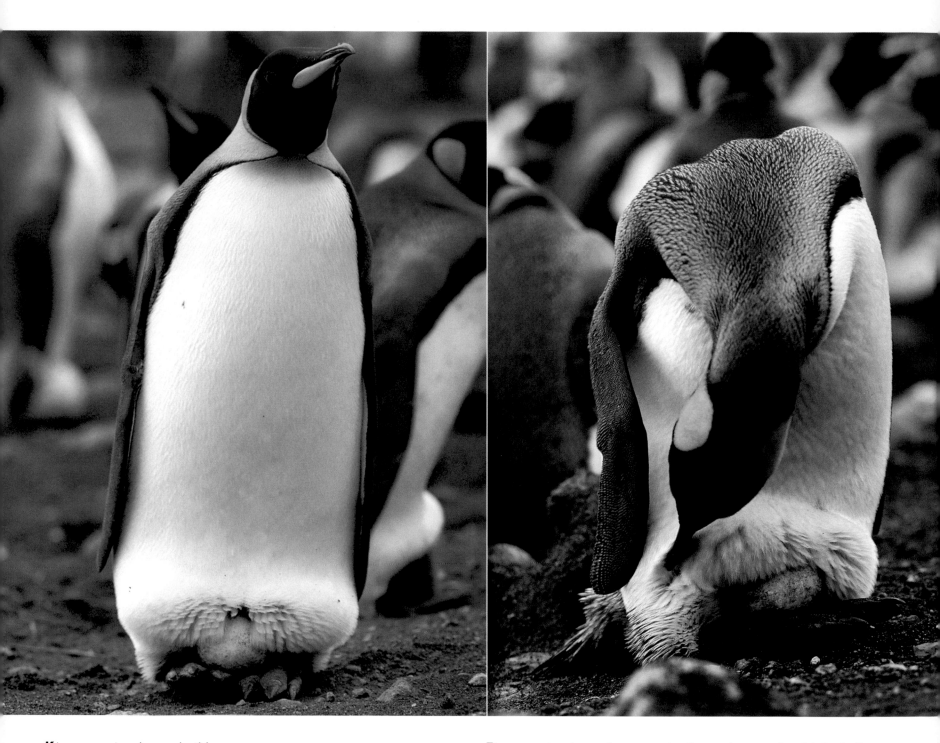

King penguins do not build nests.

The penguin places the egg on its feet and warms it with its belly.

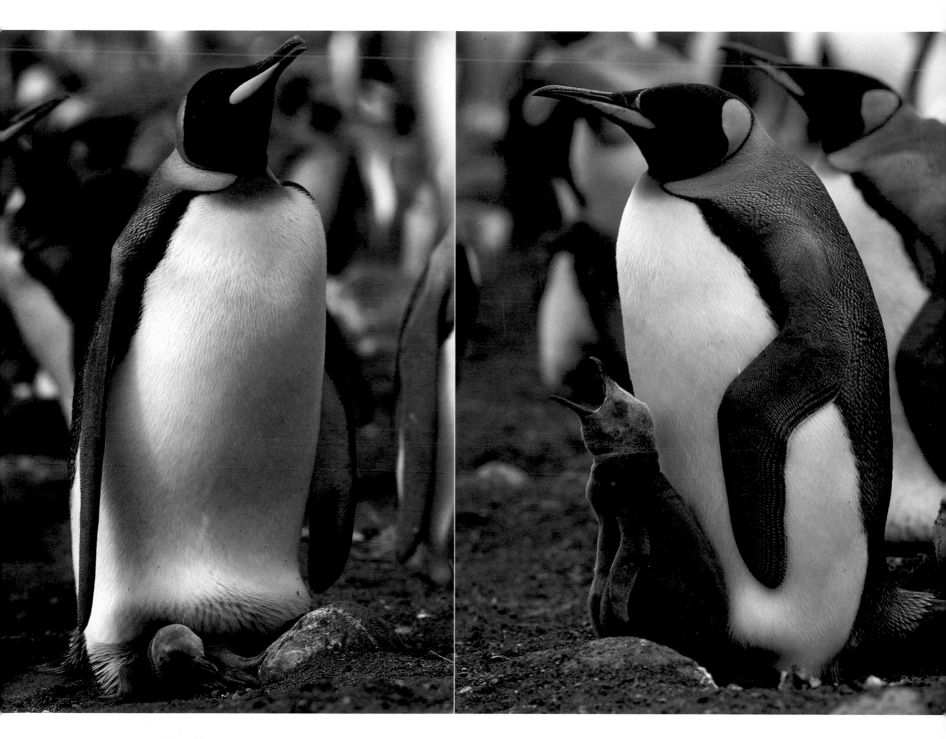

The male penguin usually keeps the egg warm.

When the chick emerges, the mother and
father penguins take turns feeding it.

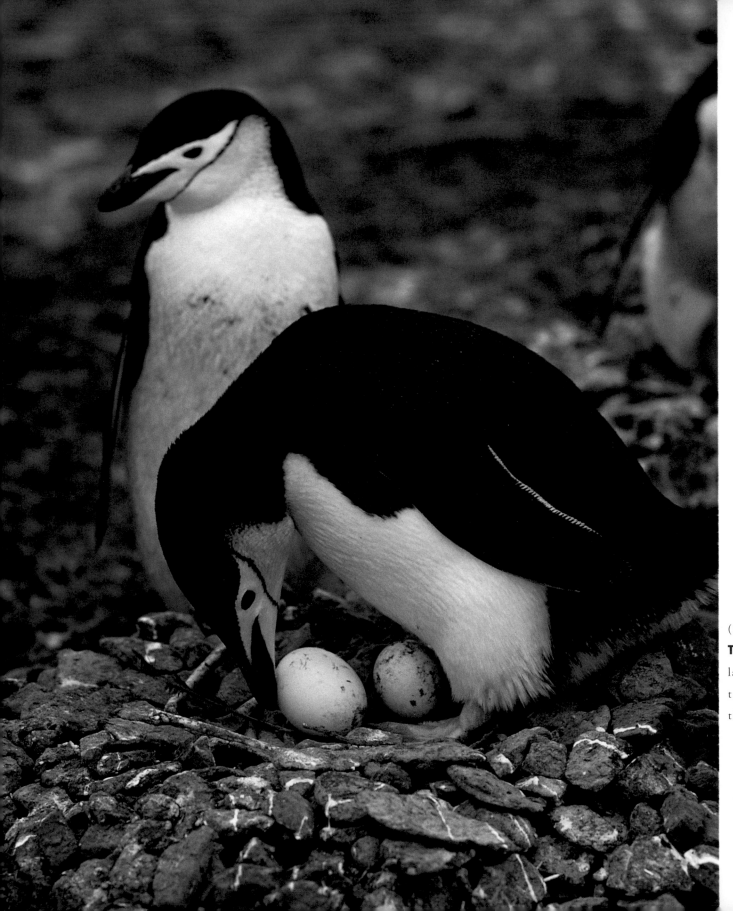

(*left*)

The chinstrap penguin
lays two eggs. The penguin
turns the eggs to warm
them evenly.

(*right*)

Young penguins, two to
three months after hatching,
are secure and growing.

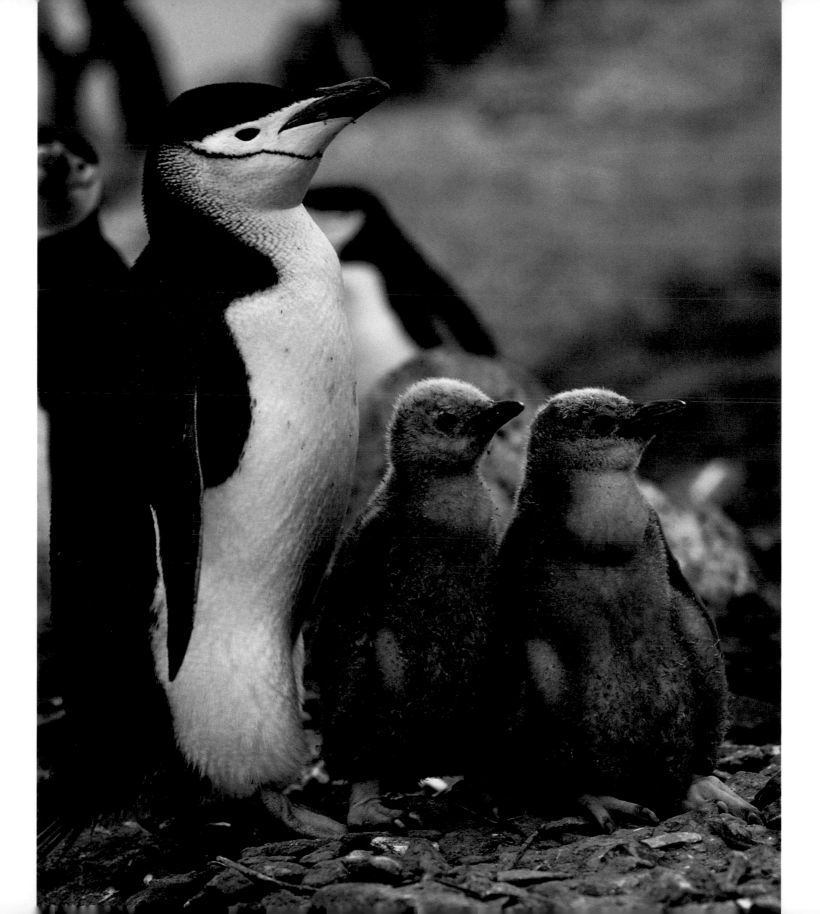

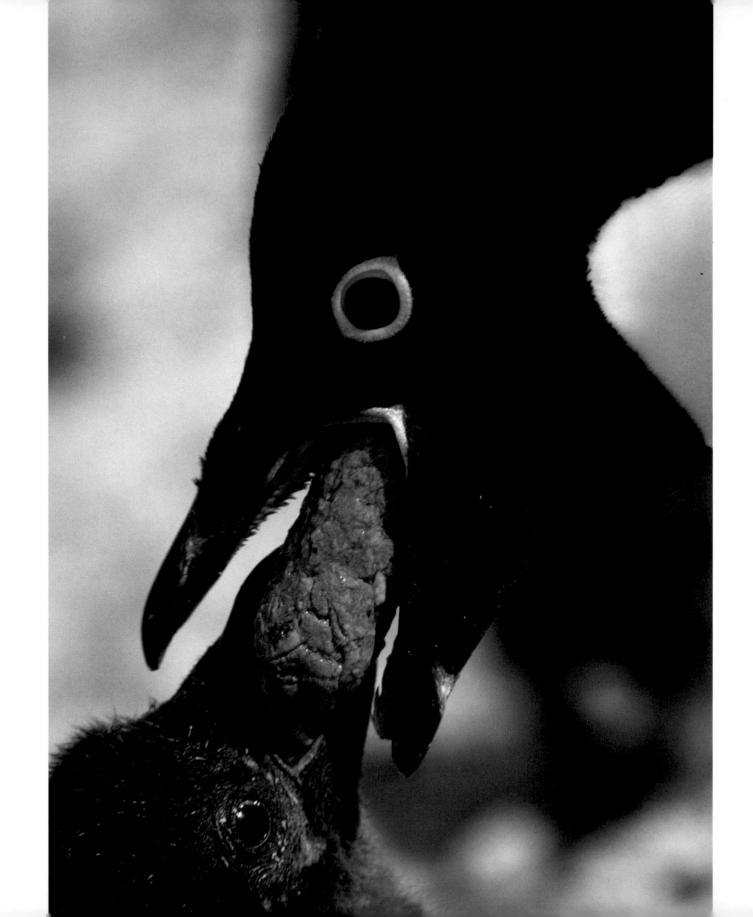

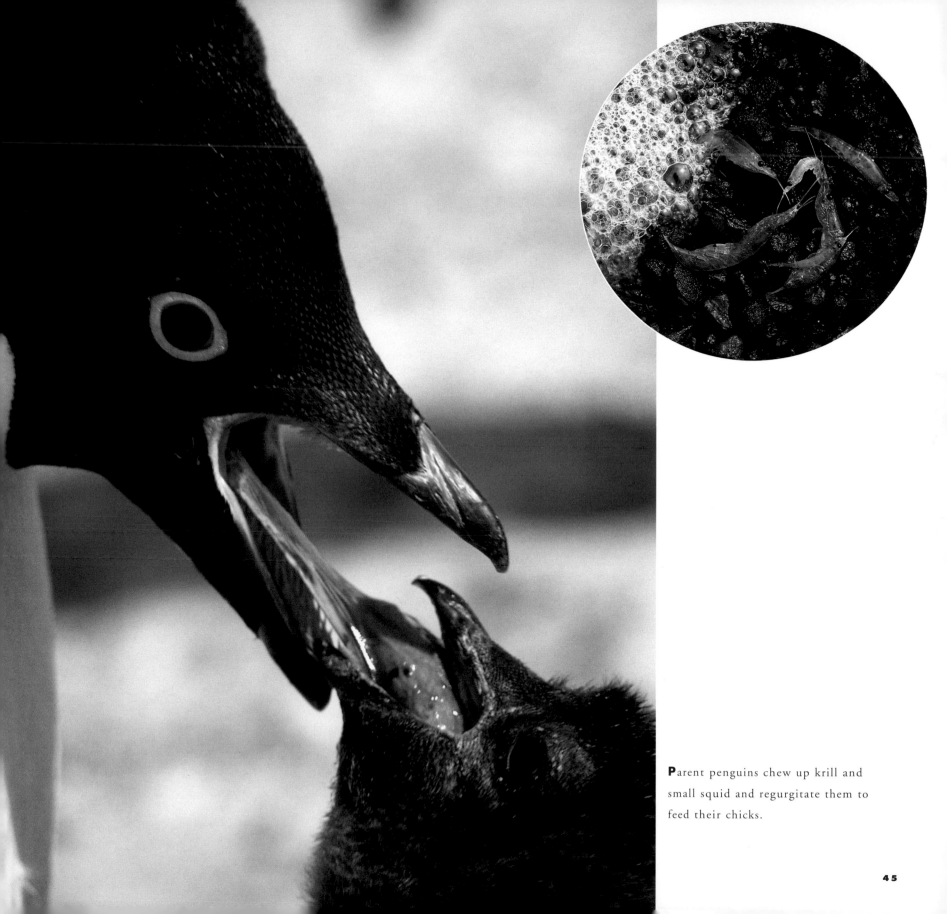

Parent penguins chew up krill and small squid and regurgitate them to feed their chicks.

45

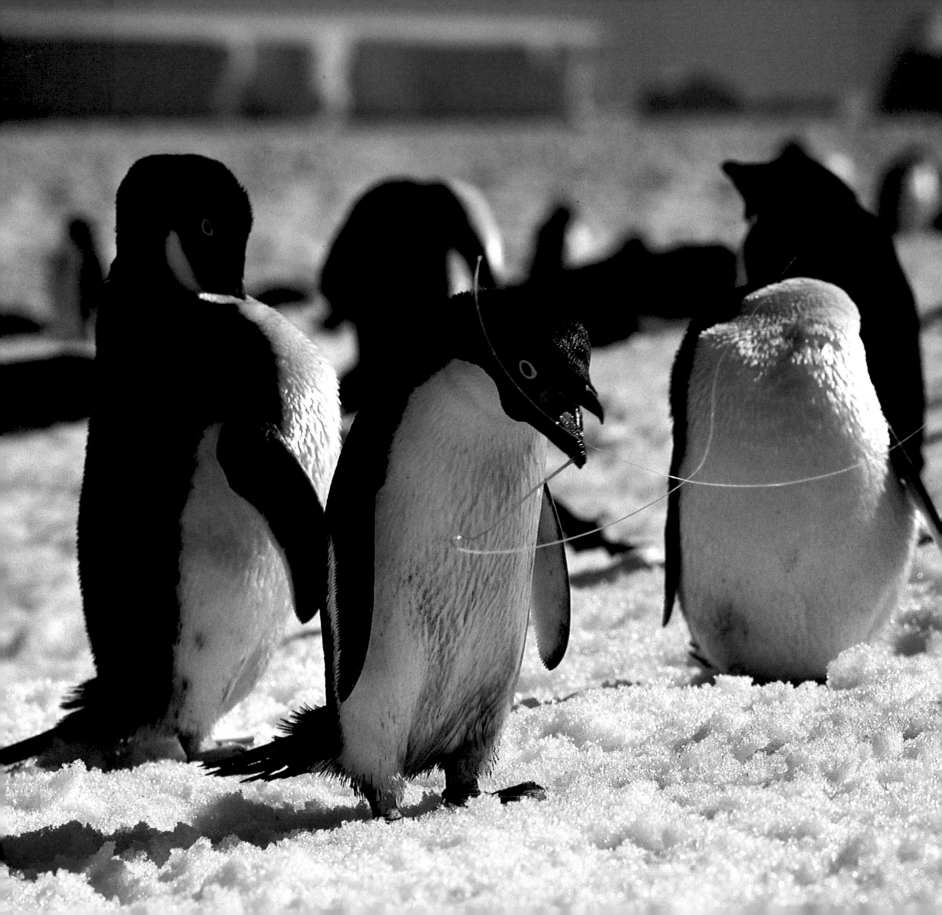

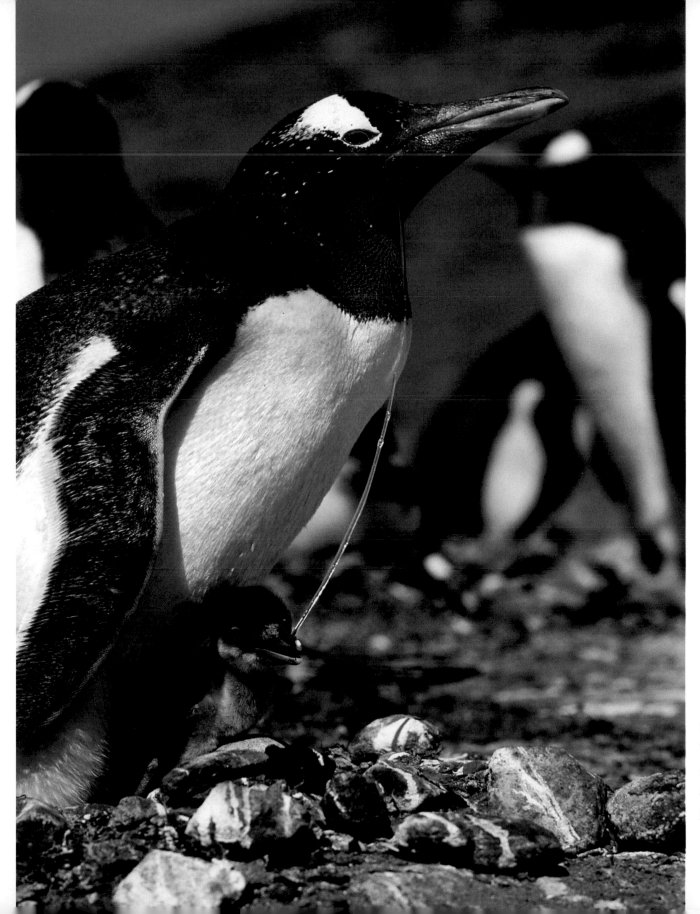

Gentoo penguins. While in the nest, the chick never strays from its parent.

47

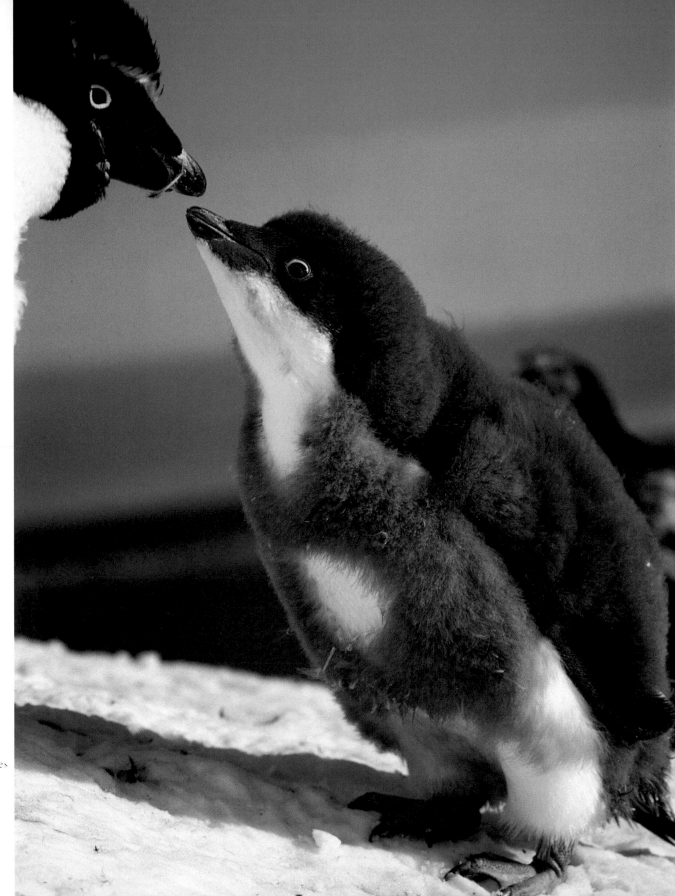

(*right*)

This young penguin has grown a lot.

(*opposite*)

The parent penguin reinforces the nest with small stones.

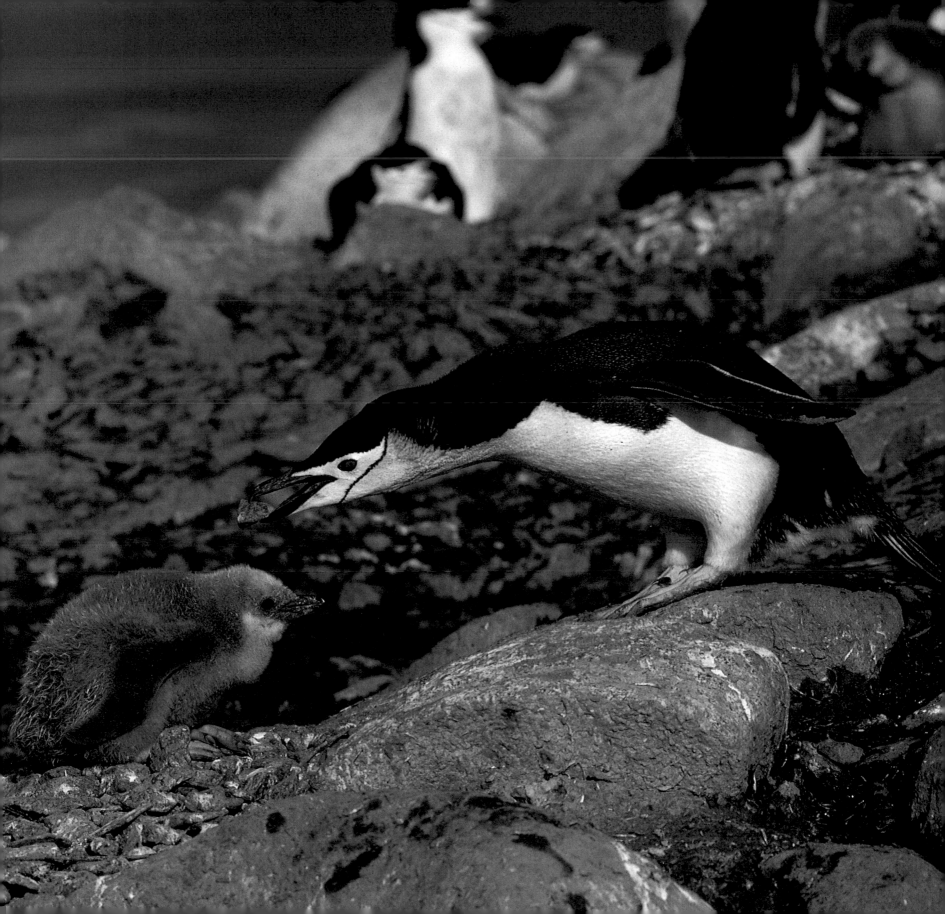

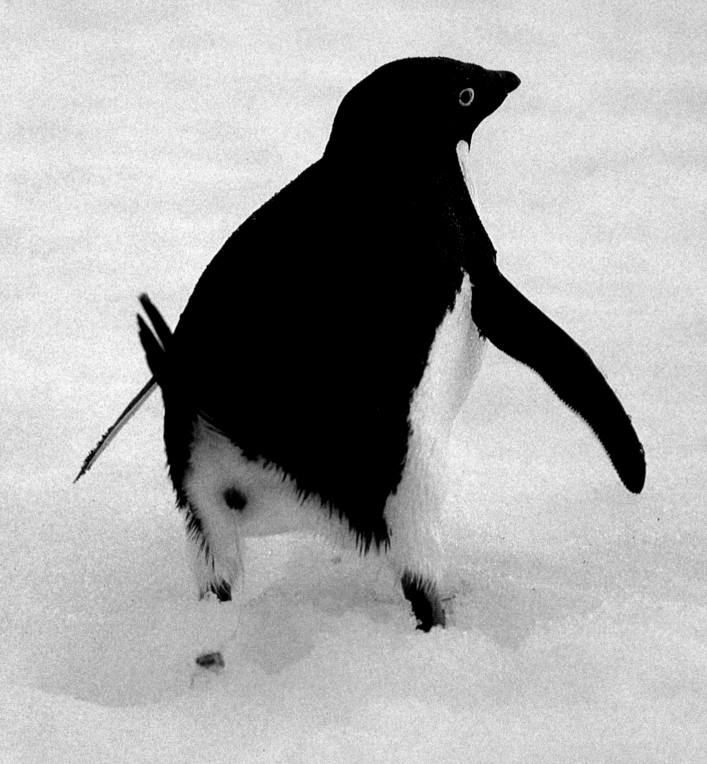

A penguin bowel movement. All of Antarctica stinks of penguin poop.

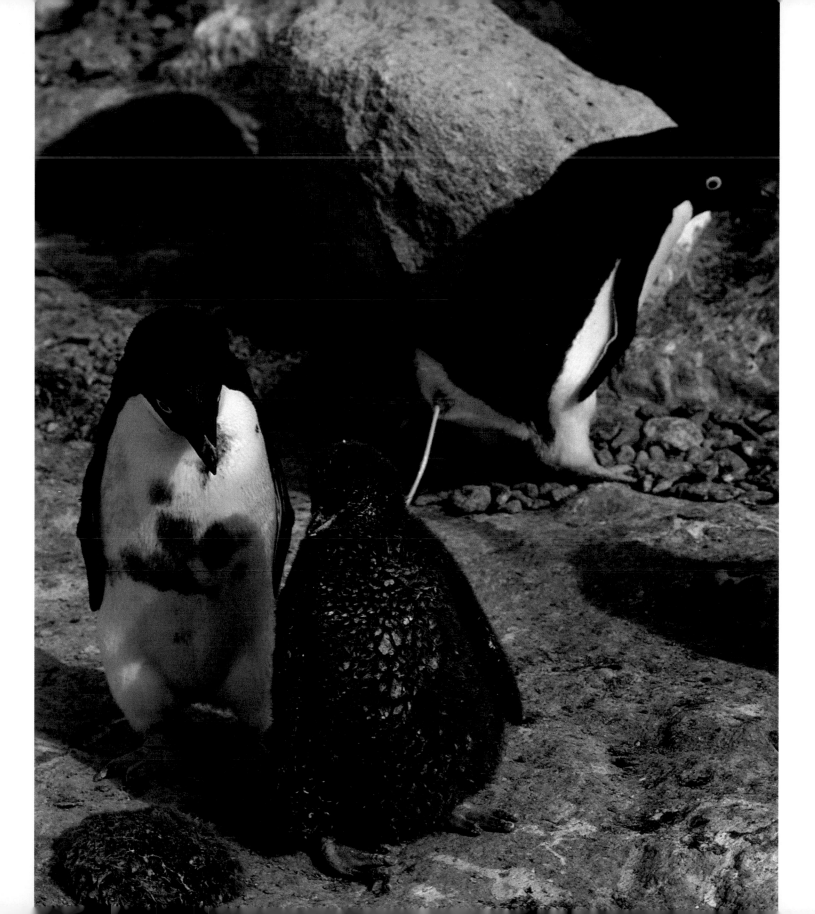

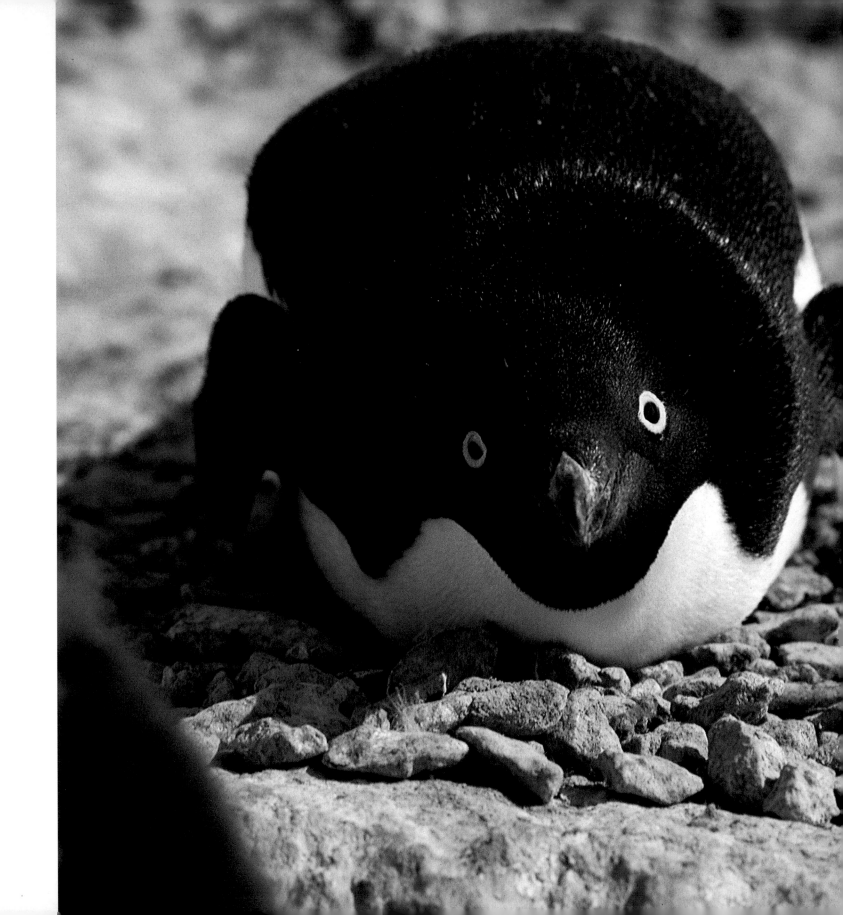

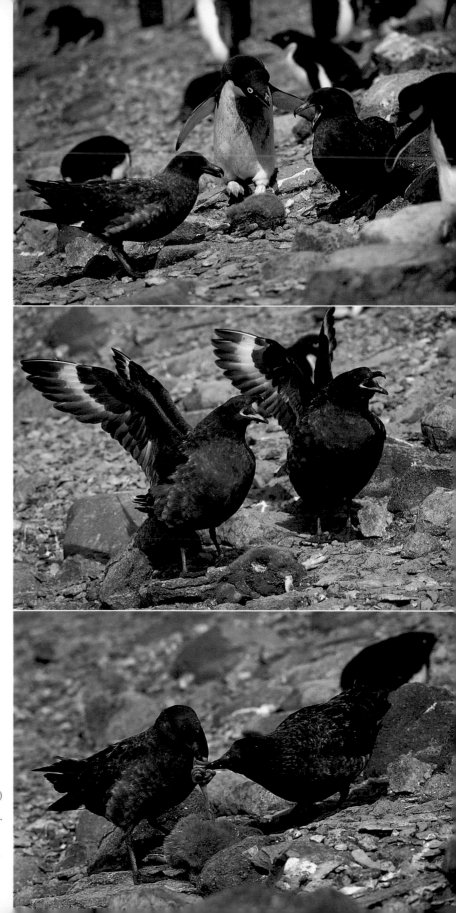

(*left*)

A penguin goes on guard, its head feathers sticking straight up.

(*right*)

Skuas attack a dead Adélie penguin chick.

EMBRACED BY
ANTARCTICA

Summer, 16 February 1991.

For the first time in my life, I have slept in Antarctica. I started gathering information on the Antarctic in 1973, and now, on my fourth visit, I have had my first opportunity to stay here, in a tent, for three weeks. I thought it best to set up a tent to get the feel of Antarctica, the only land on earth that no one owns. With my own skin, I wanted to feel the Antarctic in a way I would never understand if I stayed aboard a ship or at a base.

Our camp was located on Ross Island, where Mount Erebus, our planet's southernmost active volcano, stands. On the first day the sea was as flat as a lake and totally calm—unusual for Antarctica. This made me feel at ease, thinking "at this rate, three weeks of field work should be just fine." I slid into my sleeping bag, feeling a warmth

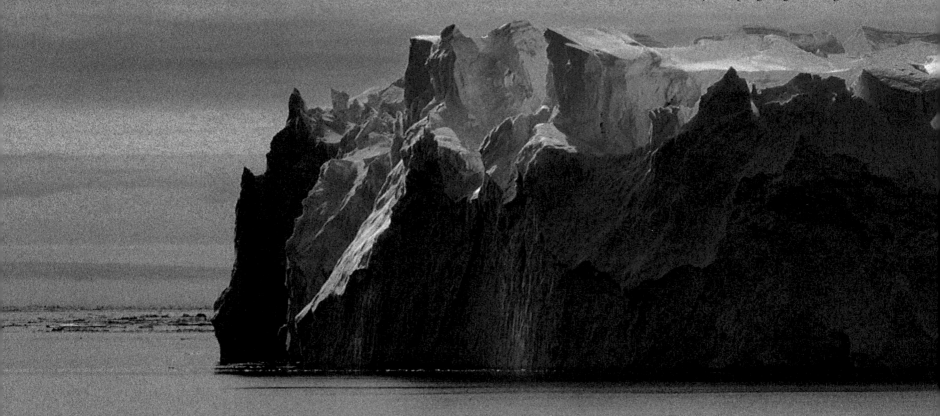

An iceberg, almost a mile long and 165 feet high.

toward Antarctica that came from my very back. The next morning I was awakened by a sound—*basabasabasa*. When I looked outside, two tents were in terrible shape, blown over in the snow and flapping. In the Antarctic, rough weather is the norm. Latitude forty degrees south is called the roaring forties; fifty degrees south, the screaming fifties; sixty degrees south, the fearsome sixties. In the end, we had only two calm days: our first and our last.

There were five of us who camped out in tents: the Australian coordinator and adventurer, a New Zealand photographer and our venture's equipment caretaker, our chartered helicopter pilot, a Japanese television director, and myself. Each person had his own tent, so we set up five tents to live in. We cooked food on board our boat and brought it ashore in plastic containers. Of course, the food

was totally frozen, so we opened one container at a time, heated up the contents, and continued eating it until we finished it. We had spaghetti three days running. But no one complained about the meals, because not much else was available at our campsite.

Our days began with the preparation of tea. We went to a snow-drift that sat about 150 feet from our tents to get snow. We shoveled it into a bucket and brought it back to our tents. There were a lot of penguin feathers mixed into the snow. We removed the obvious ones as soon as we found them, but when we melted the snow on our gas stove, a lot more feathers floated to the surface. At the beginning, we removed each feather with our fingers, but as the days went by, we got used to them and nonchalantly drank "penguin tea." Next time, if I stay in a tent, I plan to bring along a strainer for

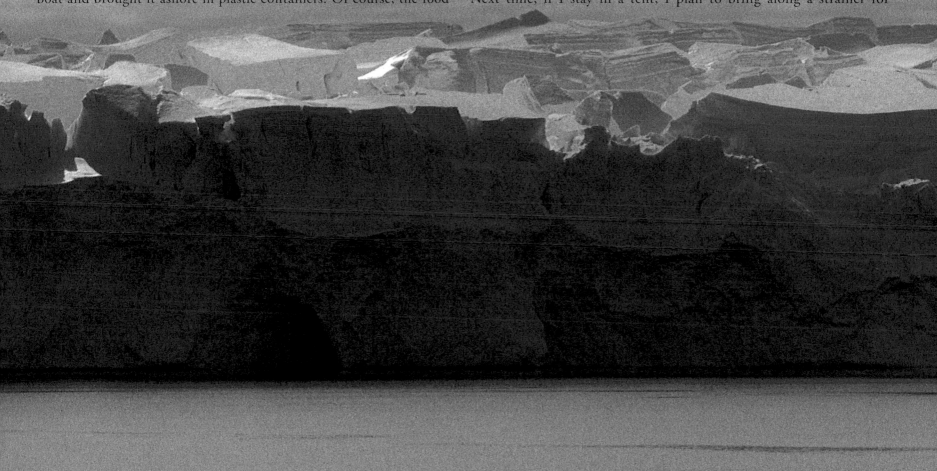

feather filtration. On each trek to the snowdrift, we brought back two buckets full of snow. Melting it yielded only four or five cups of water. Acquiring enough snow took us three hours. I cannot tell you how many good shutter chances I lost because of these snow-porting trips.

In the Antarctic summer, the sun stays in the sky twenty-four hours a day. Blizzards can rage across the land for several days. The temperature around the tents was about sixty degrees below zero. When the wind blew, it became stunningly cold, because our body heat was stripped away. The snow did not fall down from the sky to the land, but flew horizontally, parallel to the surface of the land. So the snow did not pile up around our tents, and the land itself, which was red with penguin droppings, was always exposed.

Since the weather was so often harsh, I went out with my camera, even at midnight, if the conditions were favorable. When I could not shoot, the only thing I could do was stay quiet in my sleeping bag. Every day I felt pressure, because I was not taking pictures. Even though I knew the Antarctic had raging weather, I grew fed up with its continual presence, and I could not help shouting "give me a break!" from inside my tent.

One of the main places I did my work was an Adélie penguin rookery near our tent site. There the penguins gathered together, laid their eggs, and raised their chicks. Their behavior filled our hearts with warmth. It was funny to watch a parent penguin run around the rookery, chased by youngsters who were nearly grown but still insisted on feedings from their parents. Every now and then a penguin pulled

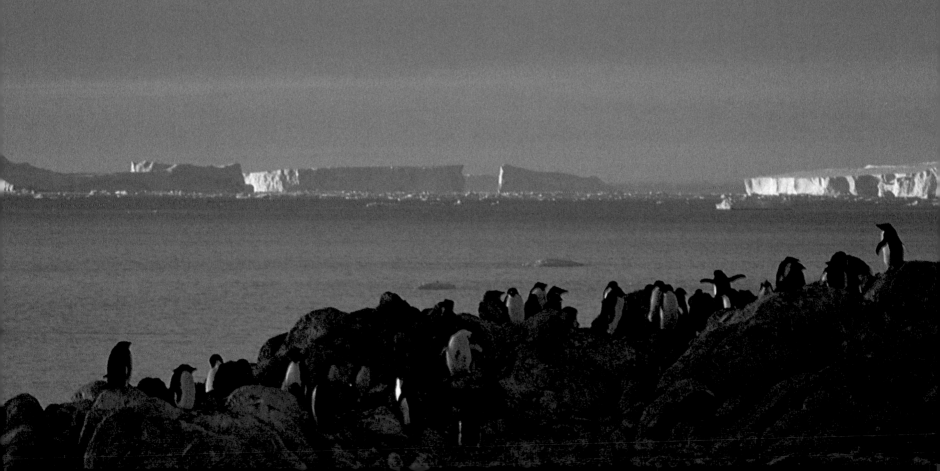

its bottom up and sprayed feces with a sound like *pyu* or *byu*. Since the droppings showed different colors, depending on what the bird had eaten, red and green lines were drawn across the snow. Penguins lying on their bellies often got red and yellow streaks across their backs, but they did not seem to worry about getting sprayed. Observing carefully, I found many penguins who showed traces of such spray. The penguins' feces smelled overwhelmingly fishy—the strong scent plainly announced the presence of a rookery in the Antarctic summer.

One day I was taking pictures of penguins while lying on my stomach. After about thirty minutes of watching penguins with all my concentration, I felt a weight on my back. I turned around, wondering what was up, and found a penguin walking across my back. It must have taken me for a rock since I was staying so still. At that moment, I could not help but adore penguins. During our stay the emperor penguins arrived by drift ice. Accompanied by our Australian staffer, I went to take pictures of them. My companion moved from the land to the ice floe and, as I put my feet into his footsteps, I felt my body gradually sinking. The drift ice was like corn ice; my feet sank fast and I was soaked up to my waist in Antarctic ice water. Under this soft ice was the sea, and I knew seals were swimming down there. The story of a man whose leg was bitten by a seal flashed through my mind. The man fell through Antarctic ice, just like I had and was bitten by a leopard seal and seriously injured. Our Australian assistant was laughing as he watched me sink and did not try to help. Committed to taking pictures of

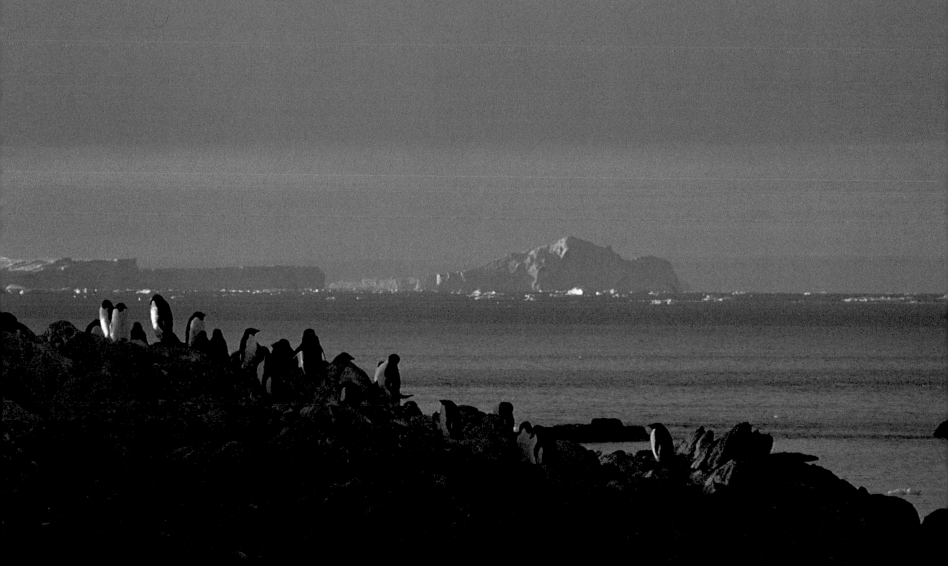

emperor penguins, I managed to climb up by myself, but my feet were freezing cold. The sea water seemed to have penetrated somewhere. I hurried back to my tent to change my clothes and returned to the coast. But the emperor penguins had drifted far away.

The fashion for Antarctic life was five layers of clothing and three layers of gloves for the upper body, three layers of pants and three layers of socks for the lower body. It was also standard to place a disposable warmer under the arch of each foot. When we worked at photography, our gloves got wet. When we walked, our socks got soaked. If we had had a heater, it would not have been any trouble to dry them—but for some reason I did not bring one with me to Antarctica. The only way to heat and dry our clothes was with our own body heat. When we snuggled into our sleeping bags at -110° F,

we took our gloves and socks with us, and we became the dryers. At first, we dried only a few small items, but as the days went on, the amount of damp clothing increased, so our "sleeping bag dryers" worked pretty hard. There is not much space in a sleeping bag, and for the latter half of our trip, I had to sleep stock-still, because clothing was packed throughout my sleeping bag.

We frequently used a helicopter to visit our locales. The pilot was a pro whose forte was flying over the poles. He never lost his calm in the face of rough Antarctic weather and always did his job without getting ruffled. Looking back, I realize it was pretty dangerous flying by helicopter to the sixty-five-hundred-foot-high Antarctic plateau. Just as the Japanese staffer who went with me landed, the lenses of his glasses cracked. It was cold in the helicopter, but it was

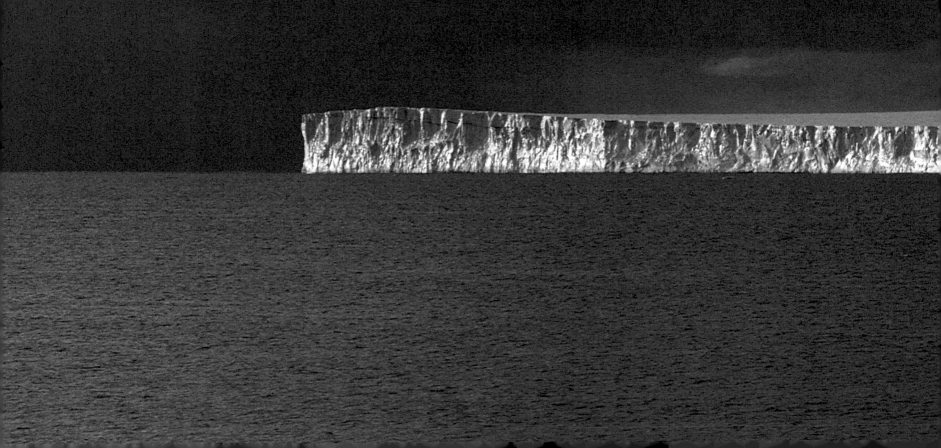

ninety-five degrees below zero outside. His lenses broke because of the difference in temperature. I went out carrying the photo equipment and walked to a position where I could shoot without the helicopter being in the frame. Perhaps because I had some difficulty breathing at that altitude, I took a deep breath without thinking. The tremendously cold air knifed into my body. I felt as if I had eaten a hundred breath mints all at once. Lightheaded, I hastily beat a retreat back to the chopper.

The helicopter left the plateau and flew down to lower heights. On the way a beautiful glacier appeared before us. Quickly I tried to take pictures of it, but I had no sense of feeling in my fingers. When I grabbed the disposable warmer I had in my jacket pocket to warm my fingers, I found it was frozen. I calculated that the effective temperature on the Antarctic plateau at that time was -160°F. According to a person at our Antarctic base, conditions on the plateau could have endangered our lives if we had been active outside for more than thirty minutes.

Tent life in Antarctica was truly a precious experience. Looking back, we had a lot of fun those three weeks. Beautiful icebergs abounded—sometimes colored in red or pink, sometimes in silver or gold. The colonies of penguins returning to the sea before it froze reminded me of the mysteries of life supported by the sea. After breaking camp, the first thing I noticed on board the ship home was the absence of a certain smell—the odor of penguin poop was indeed the smell of the land of Antarctica.

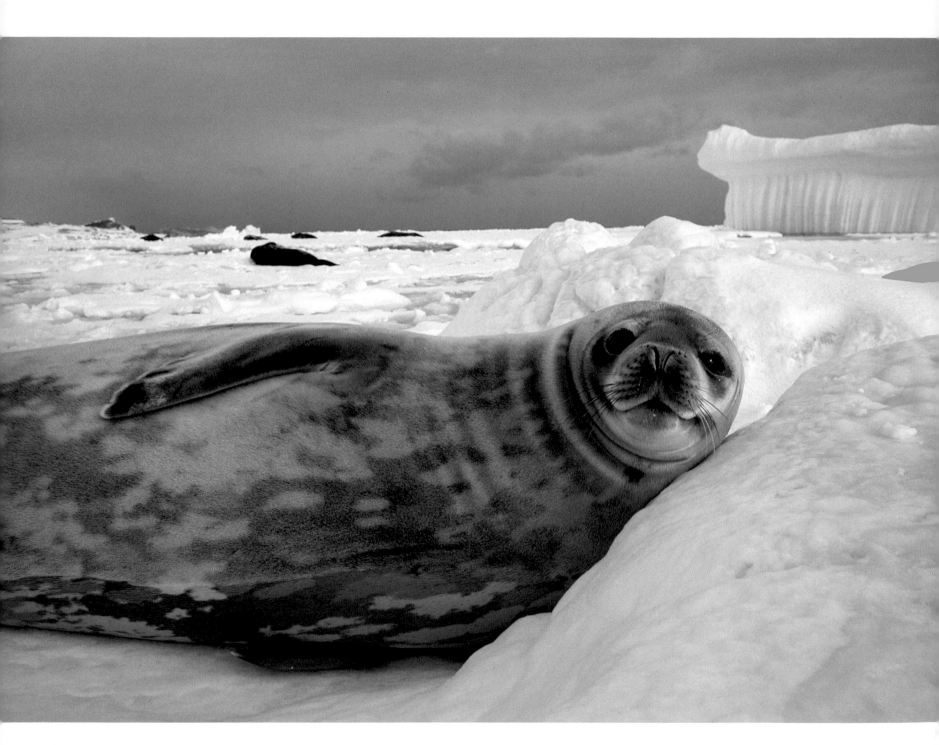

A Weddell seal who has traveled along on the drift ice.

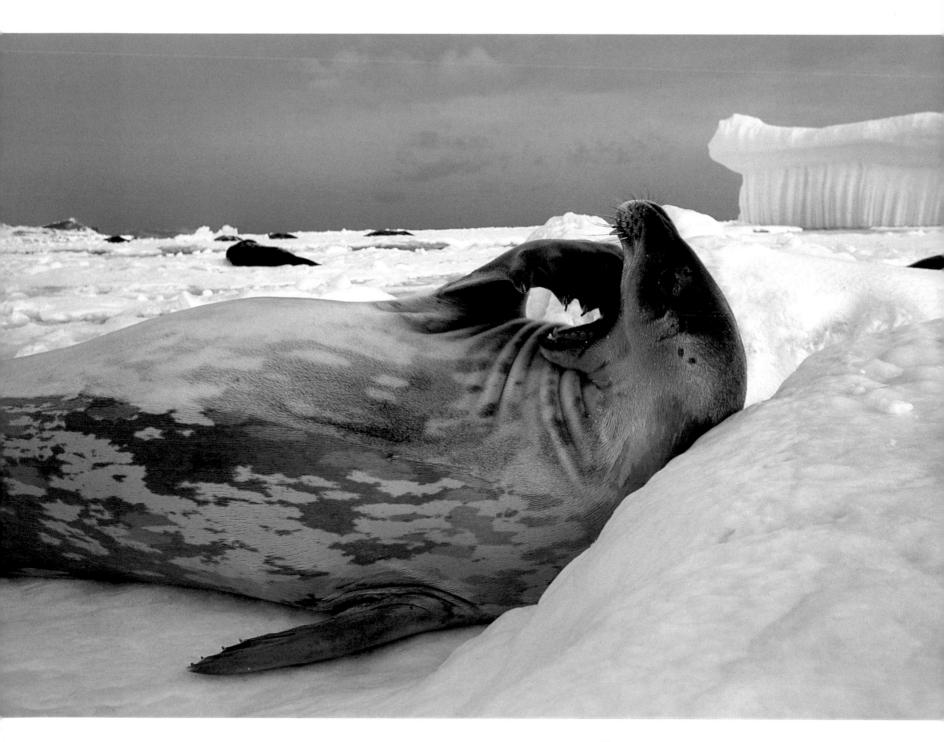

The next day, the drift ice blew away with the wind.

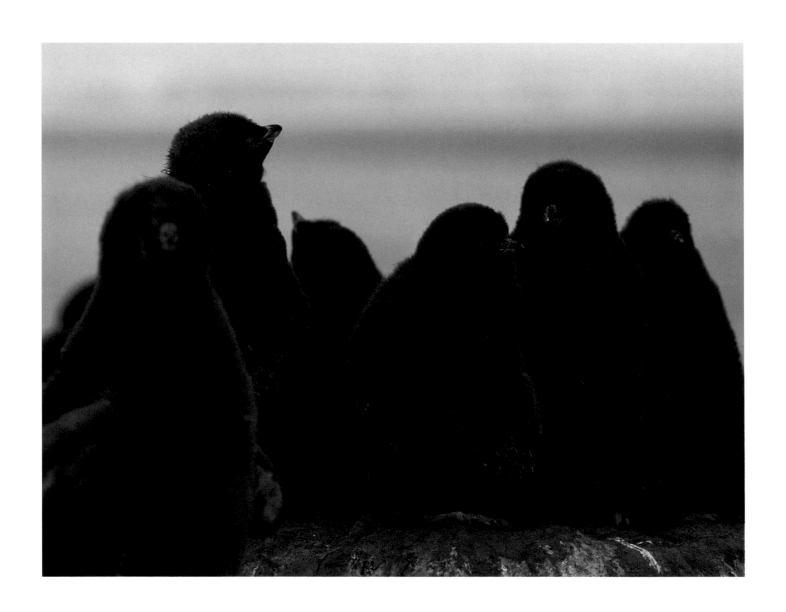

(*above*) **A**délie penguins two to three weeks after hatching. A group of young penguins is called a crèche.

(*right*) **Y**oung king penguins quickly grow up to be as large as their parents.

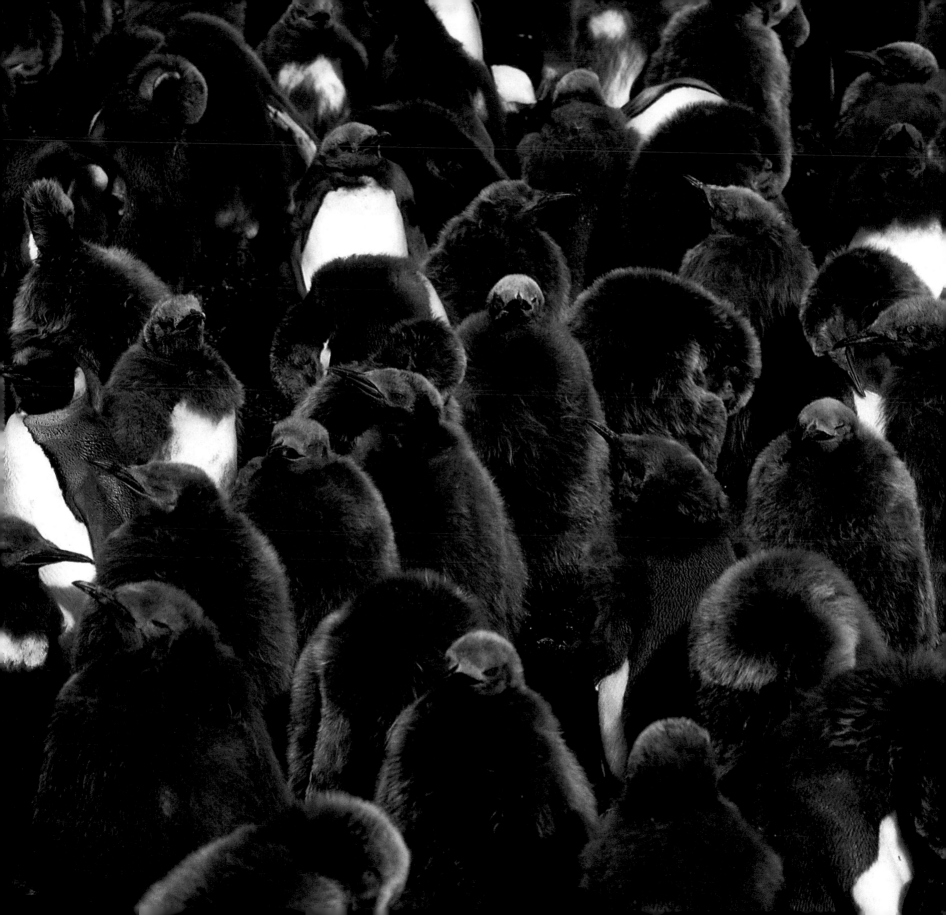

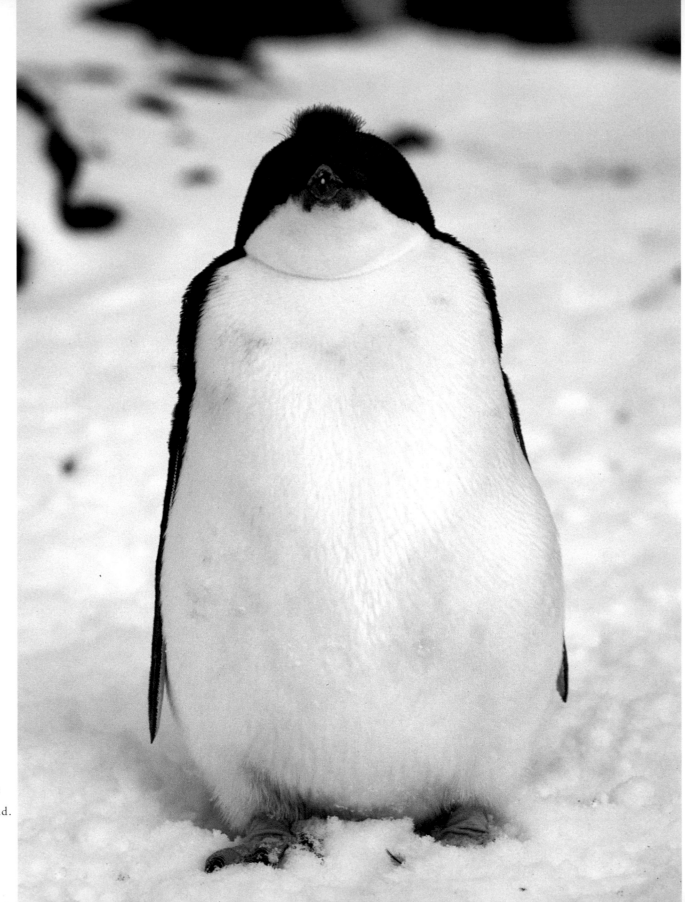

A young Adélie penguin. A bit of down remains on top of its head.

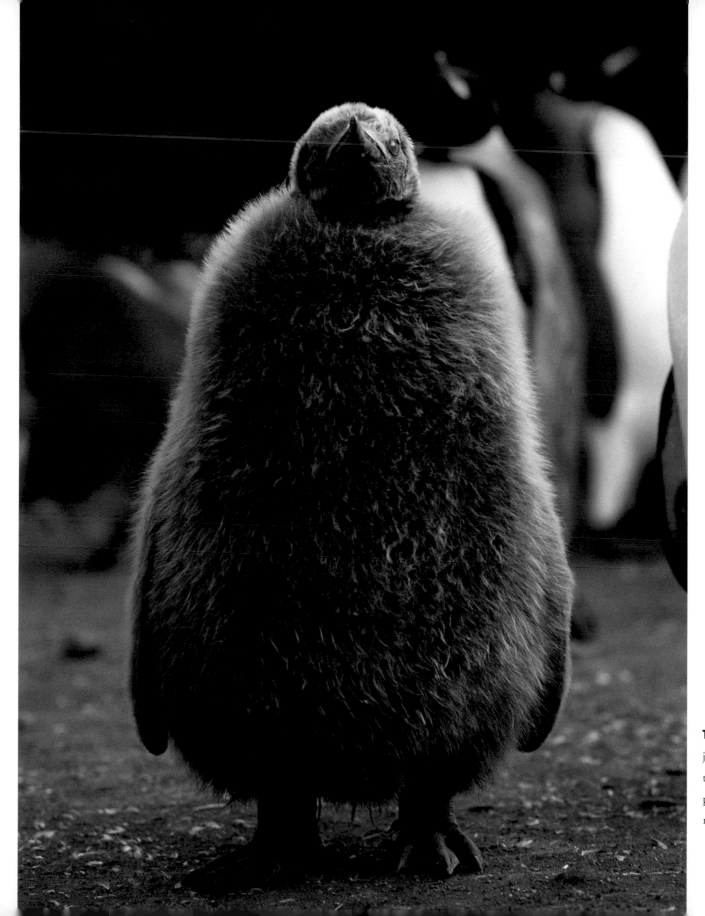

This stout juvenile is proof that a young penguin eats as much as it can.

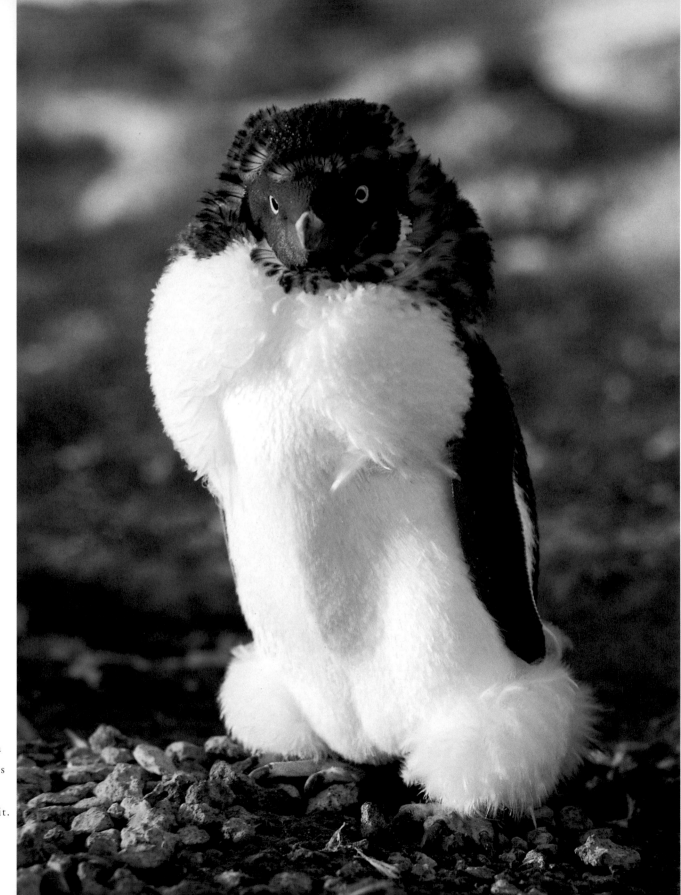

Adult Adélie
penguins. Once a
year their feathers
are renewed, and
winter pays a visit.

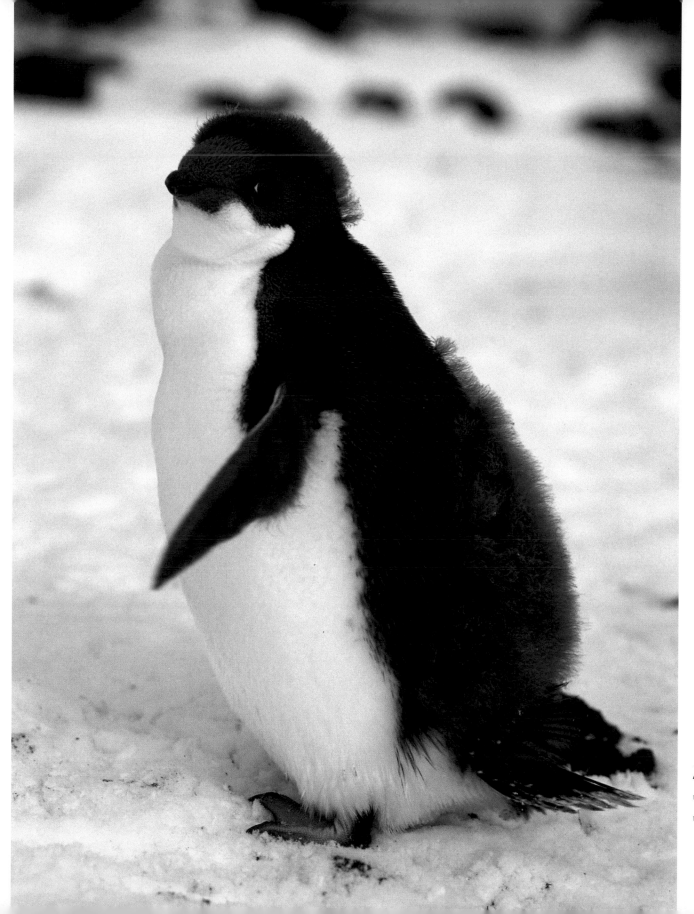

A chick still unfamiliar with the sea.

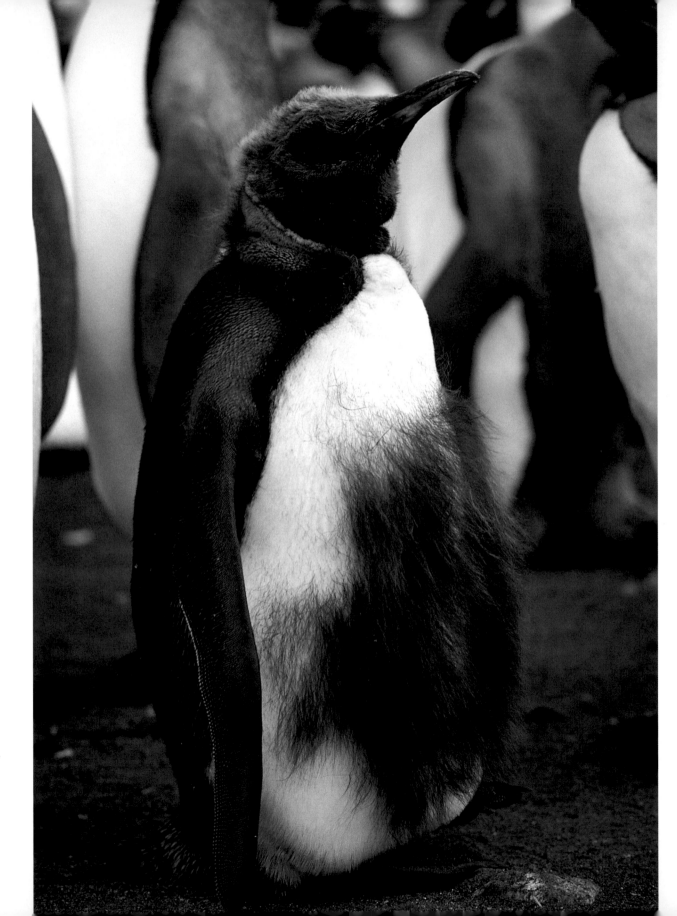

As penguins grow, the whiteness of their chests becomes apparent.

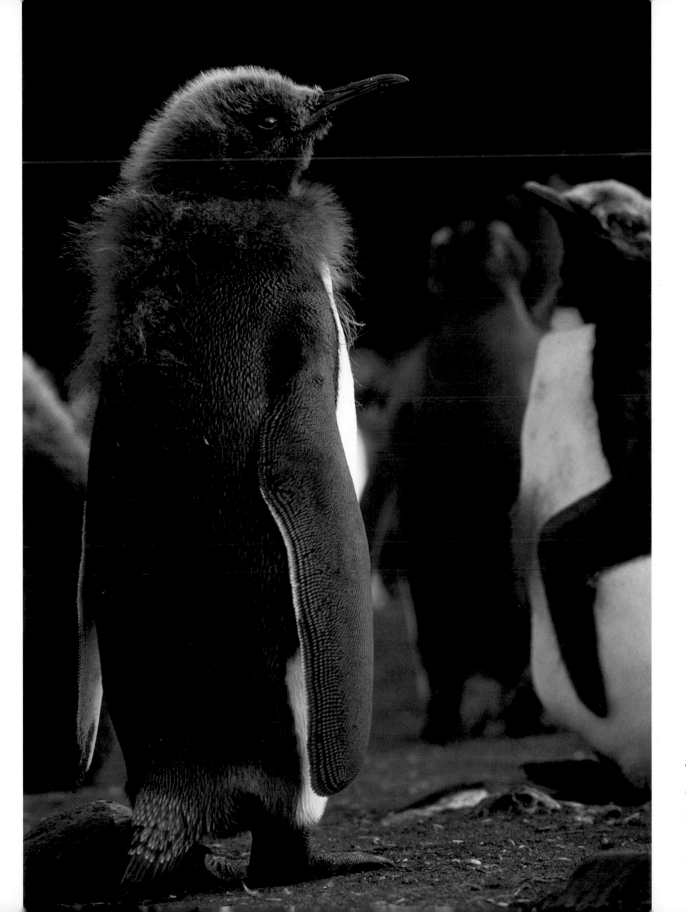

Their down falls
out in a variety of
patterns.

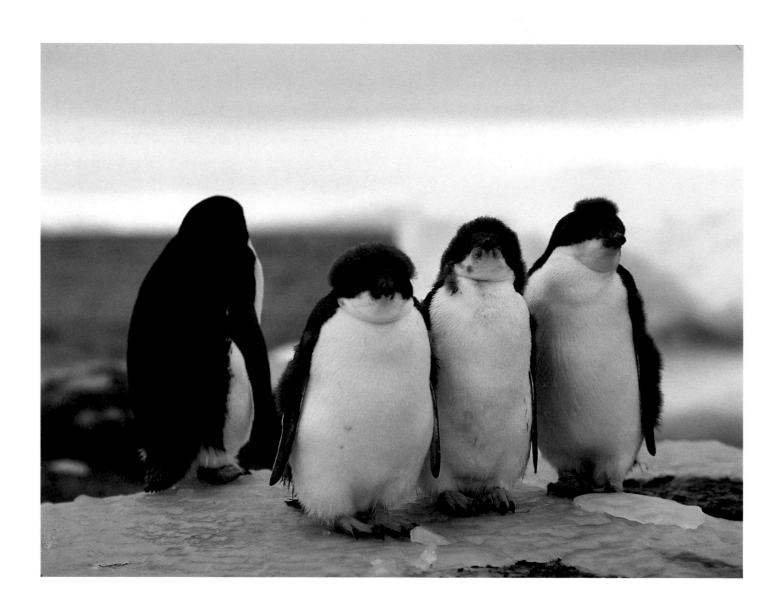

(*above*) **T**hree penguins who were born around the same time.

(*right*) **T**he surface of Antarctica is covered with penguin feathers.

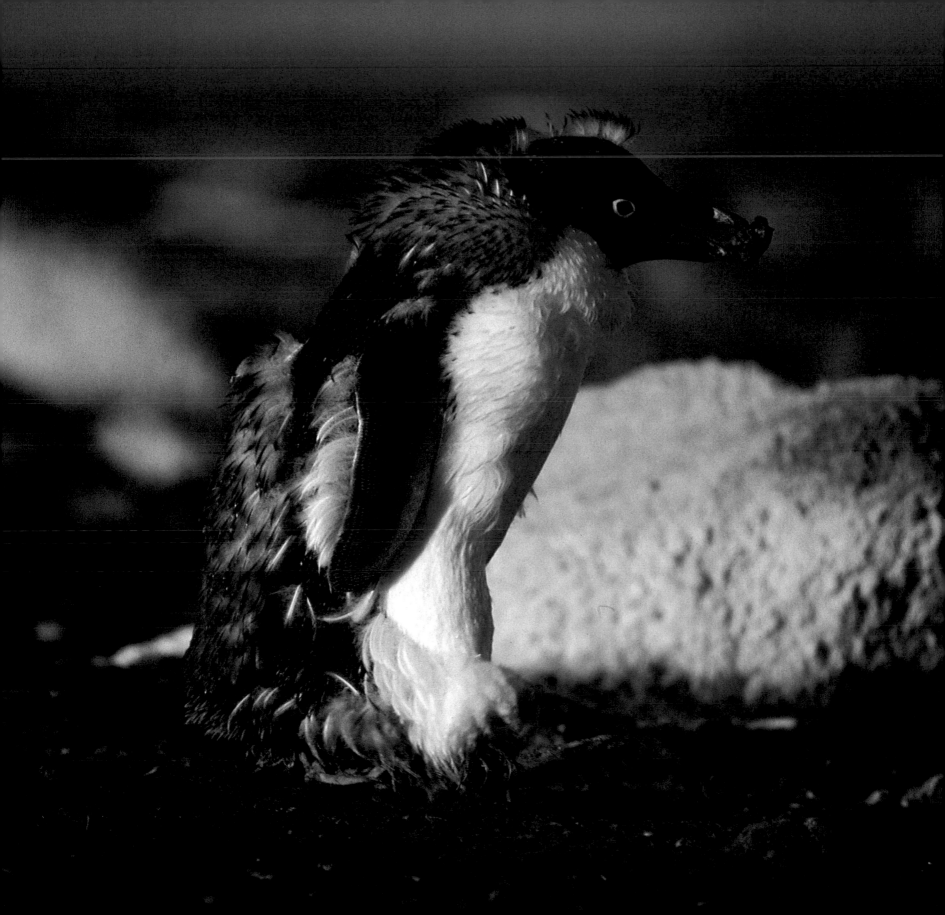

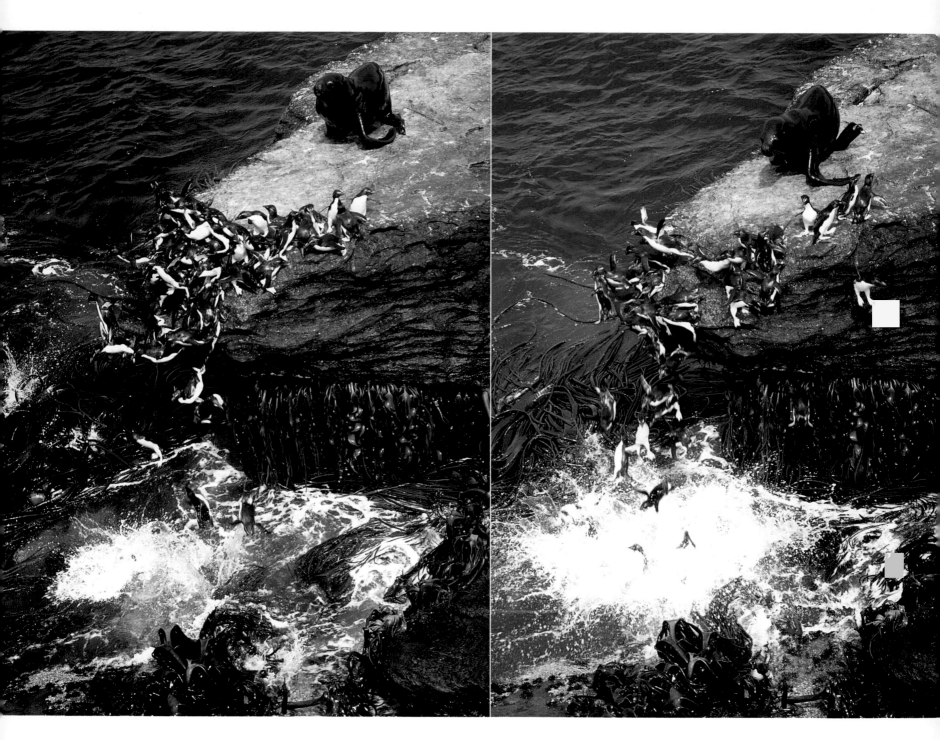

A Patagonian sea lion attacks a group of rockhopper penguins.

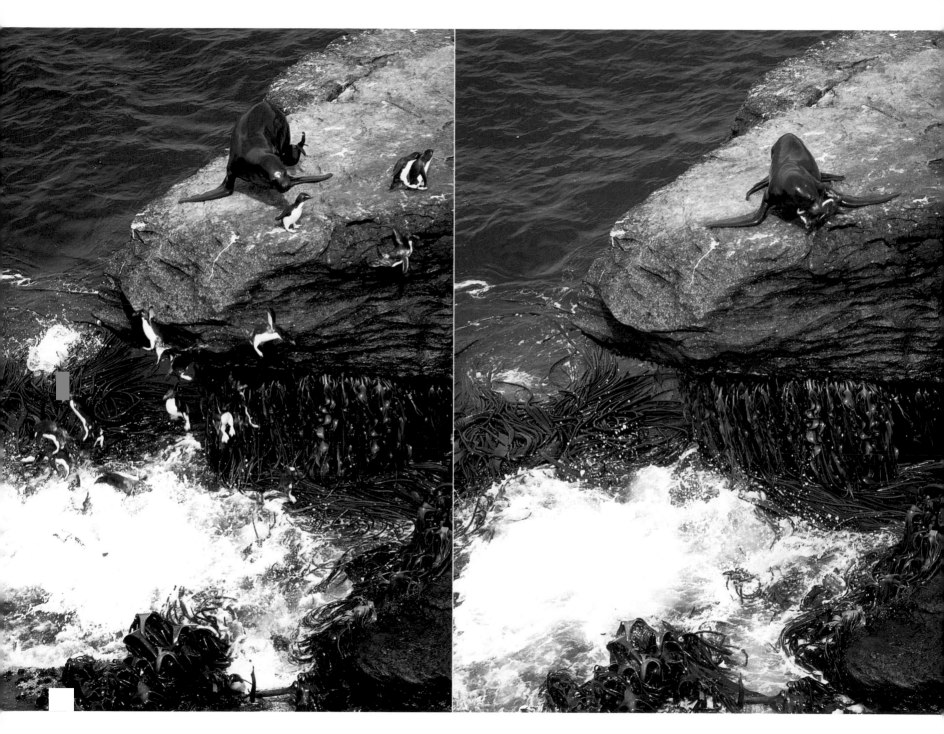

One penguin did not escape. The sea lion tore its belly open.

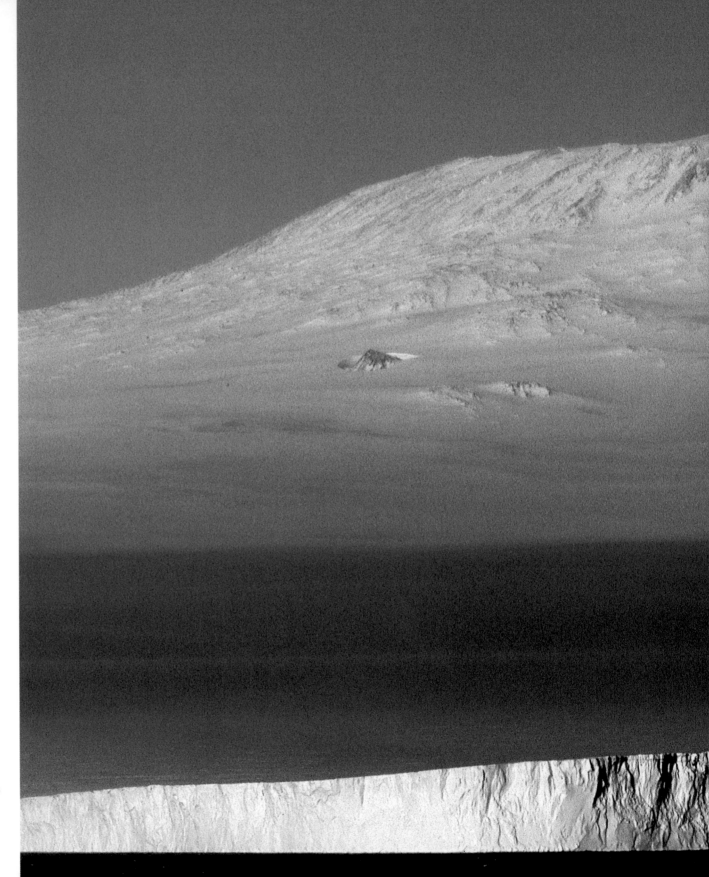

Mt. Erebus (12,280 feet high),
the southernmost active volcano
on earth.

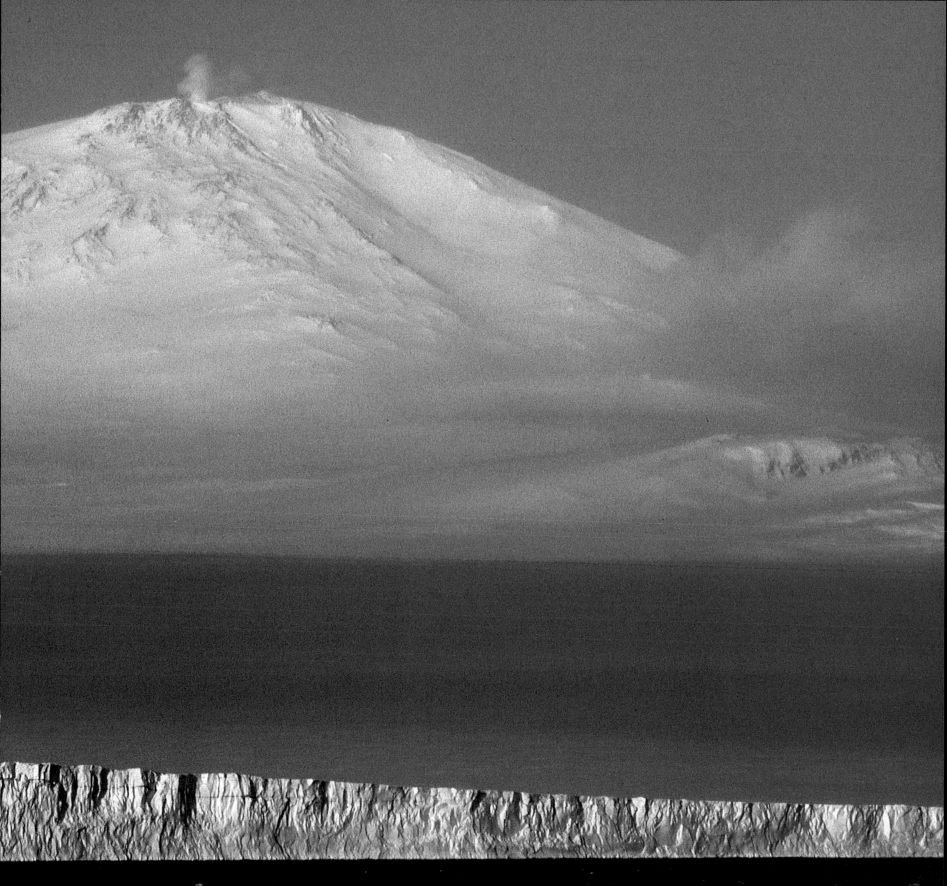

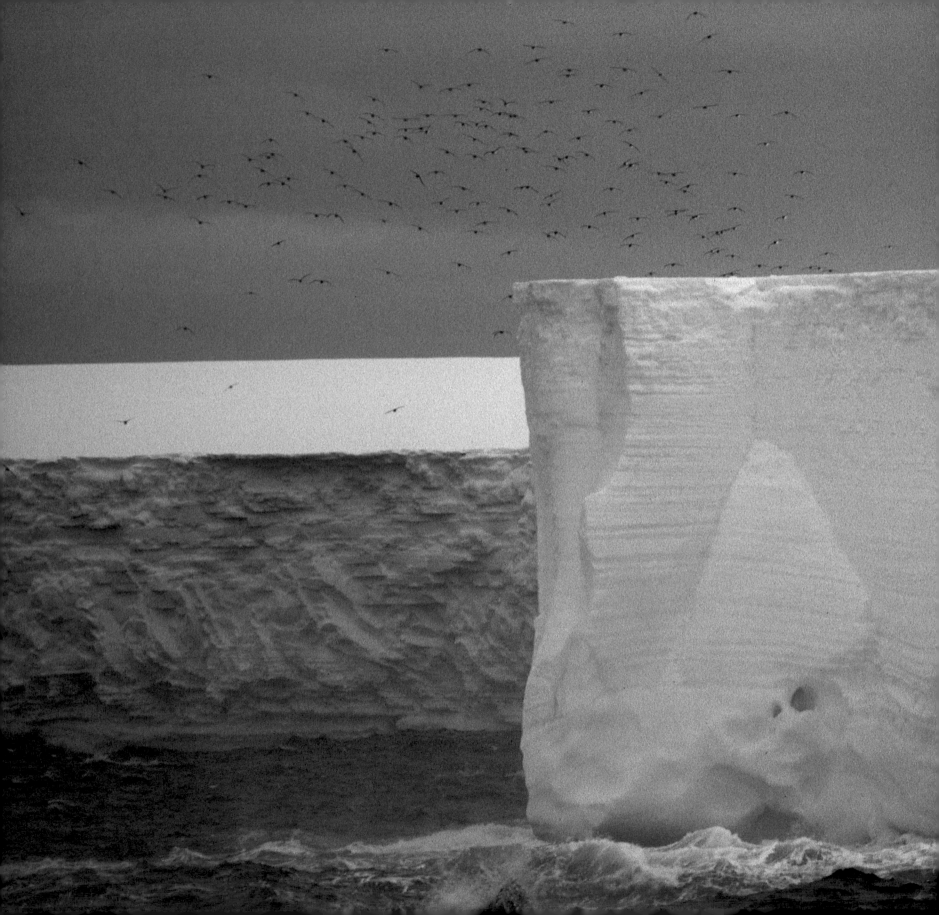

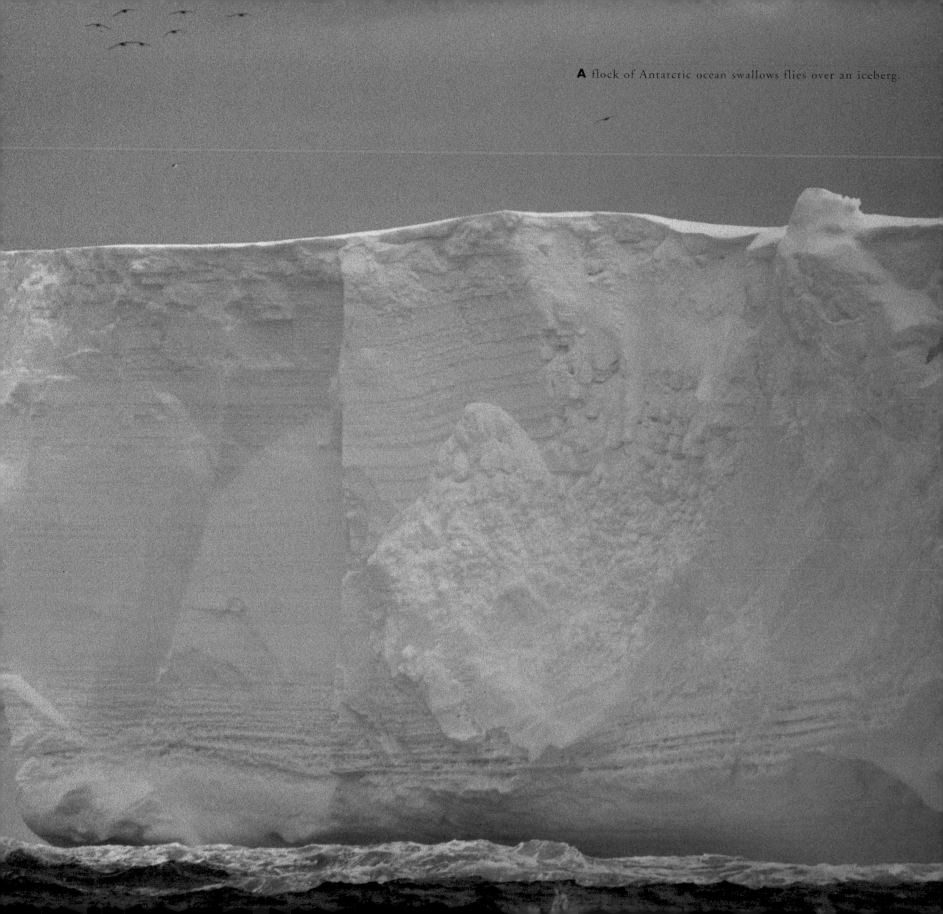

A flock of Antarctic ocean swallows flies over an iceberg.

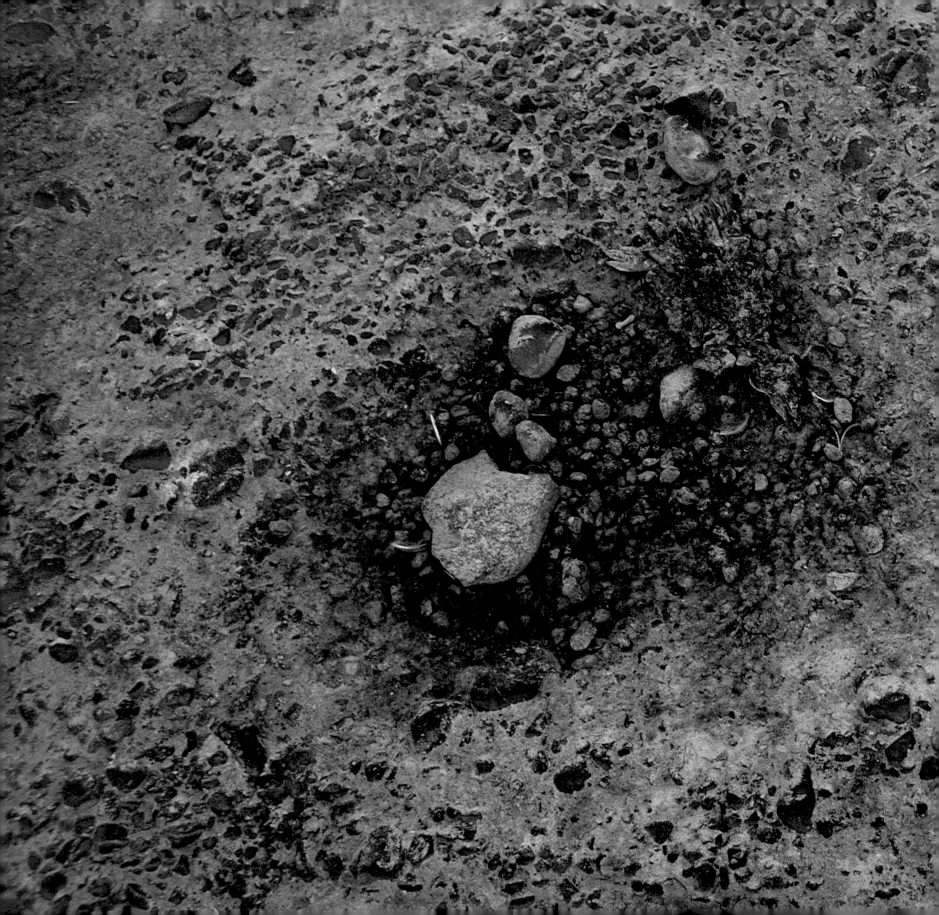

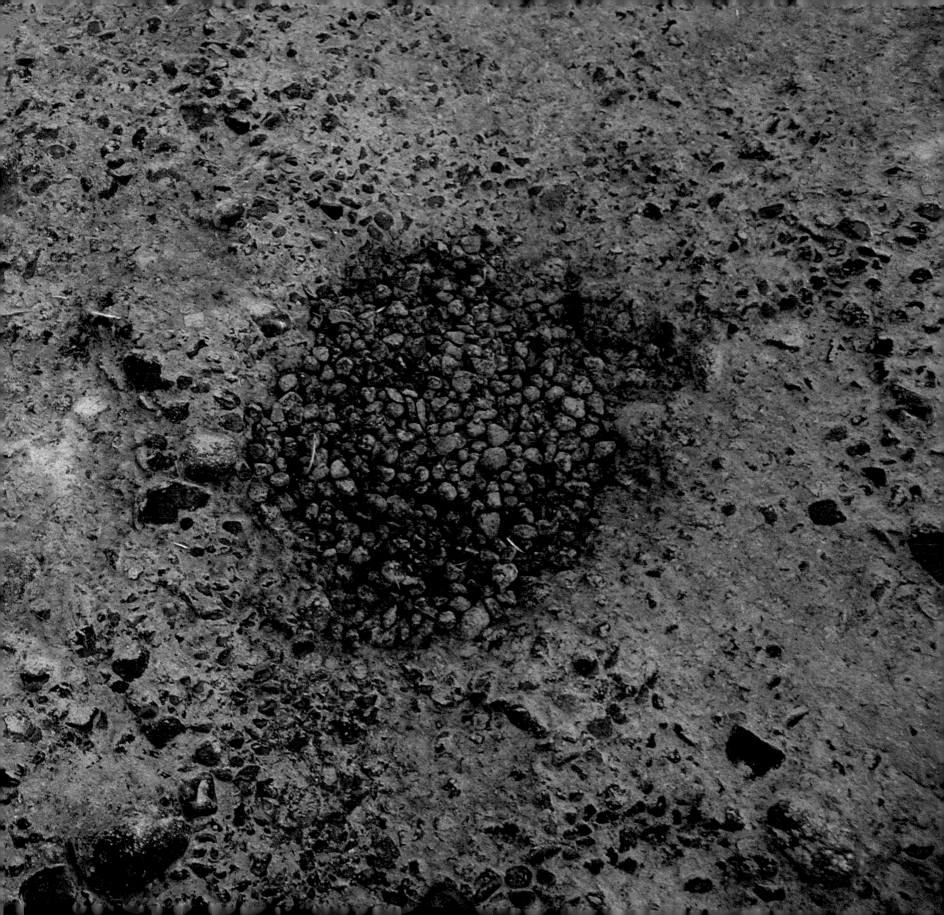

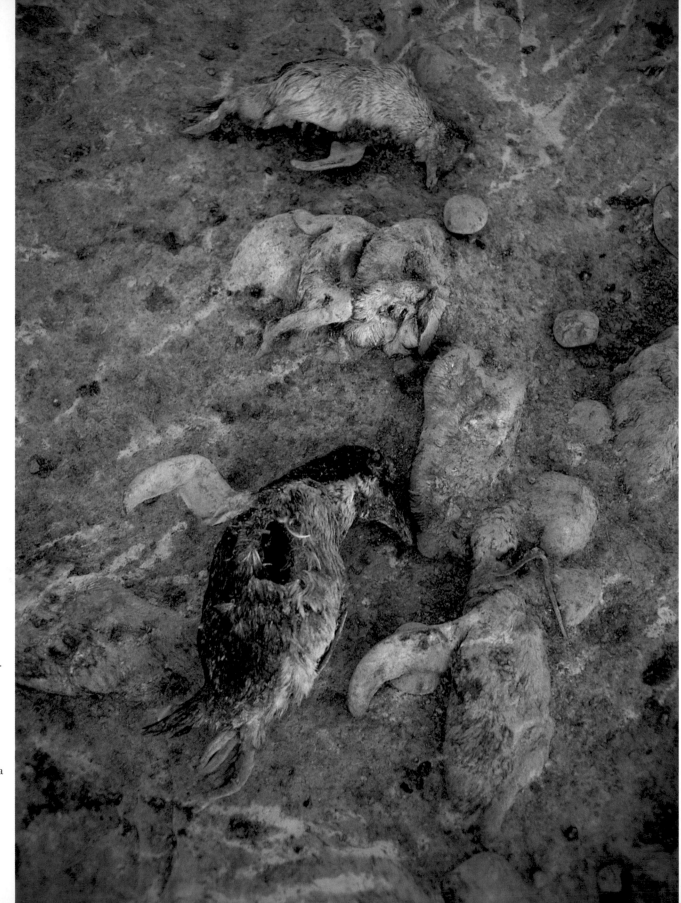

(*previous page*)
Nests after the
breeding season.

The bodies of
penguins who
were unable to
return to the sea
pile up at a
rookery.

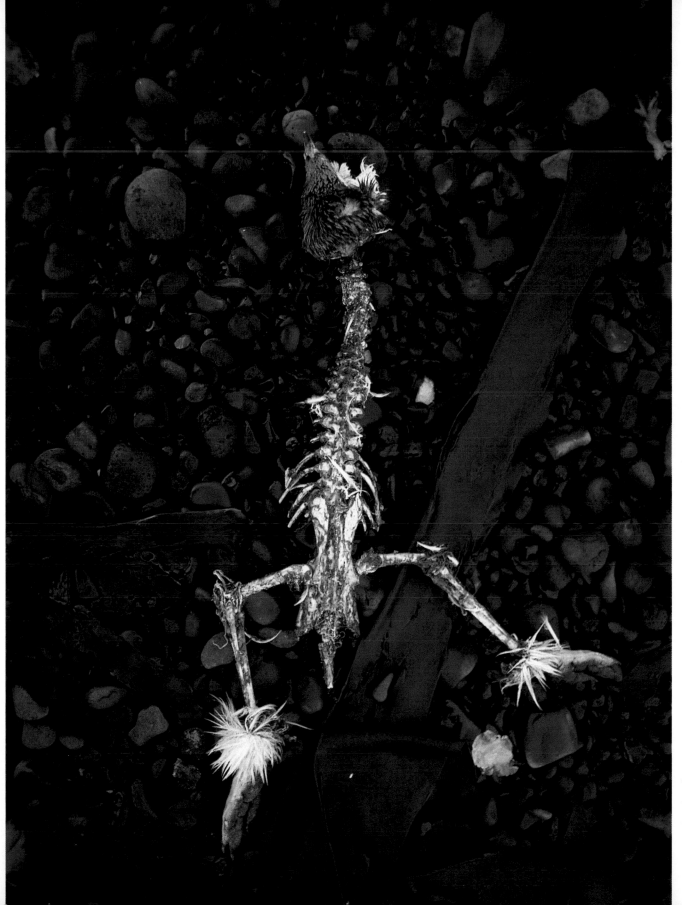

A penguin that has been eaten by skuas.

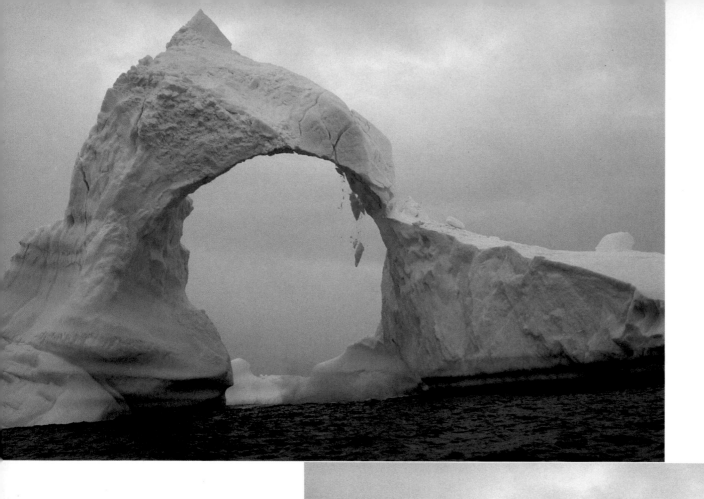

A hundred-foot-high iceberg arch starts to collapse.

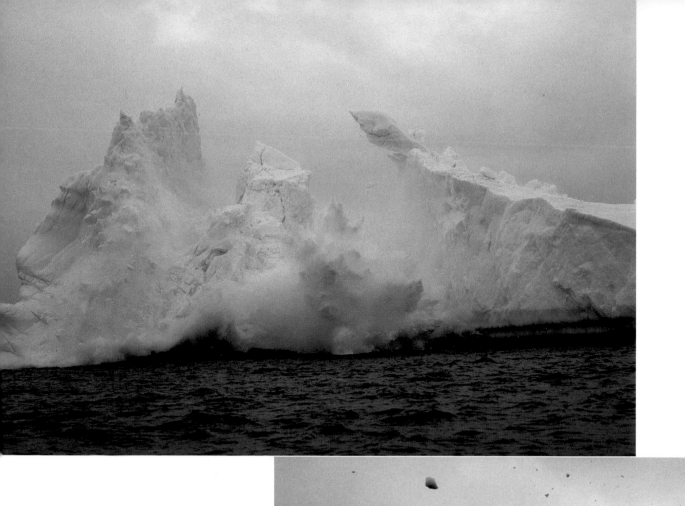

As it falls apart, the sound changes from a dry sound of *karan, karan* to a heavy, echoing *daaaaaaan*. The crumbling arch caused a wave some seven to ten feet high when it hit the water.

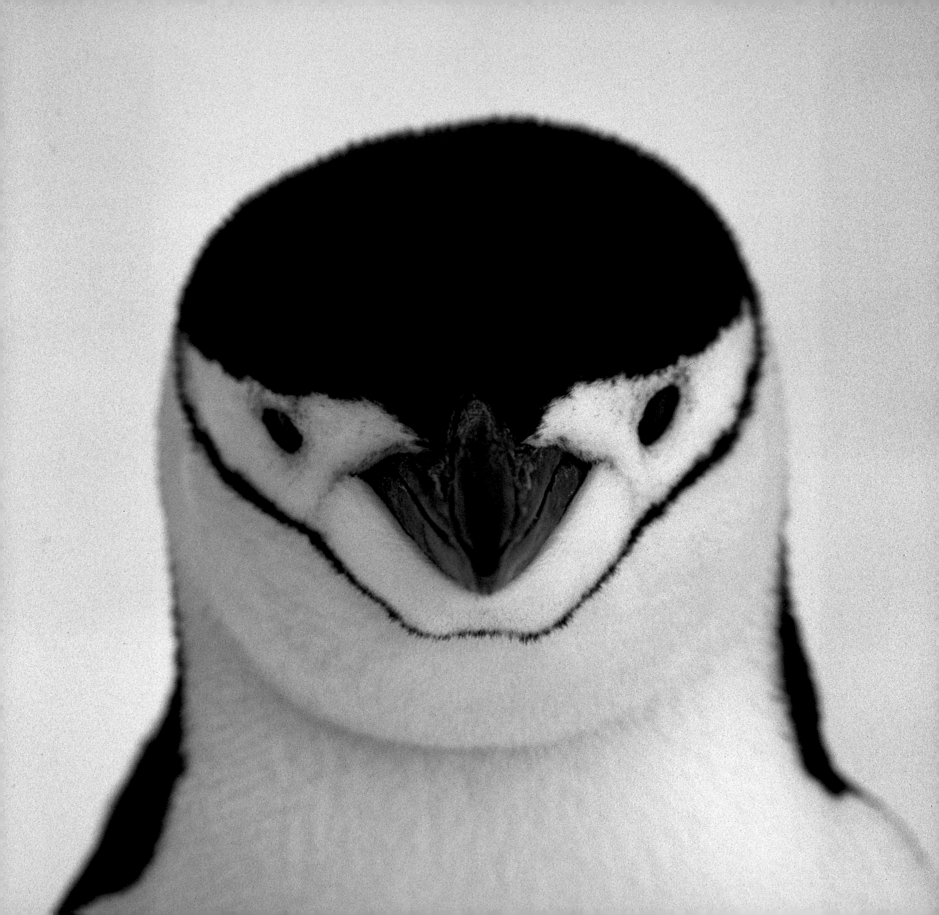

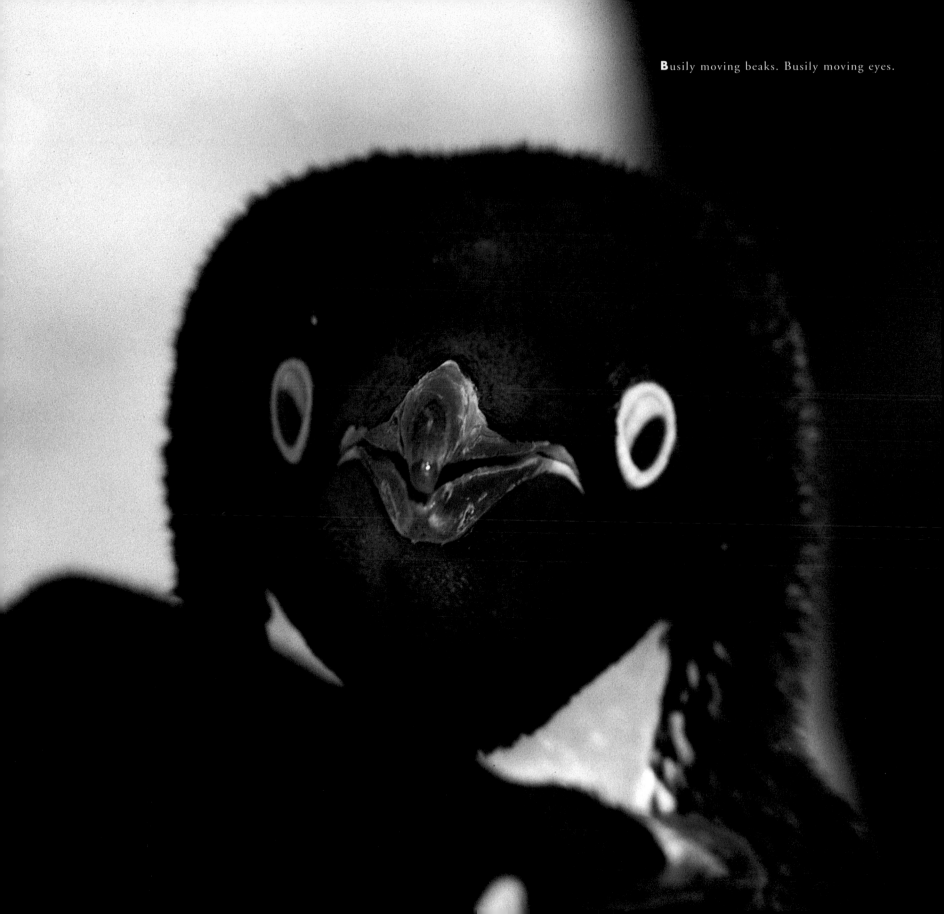

Busily moving beaks. Busily moving eyes.

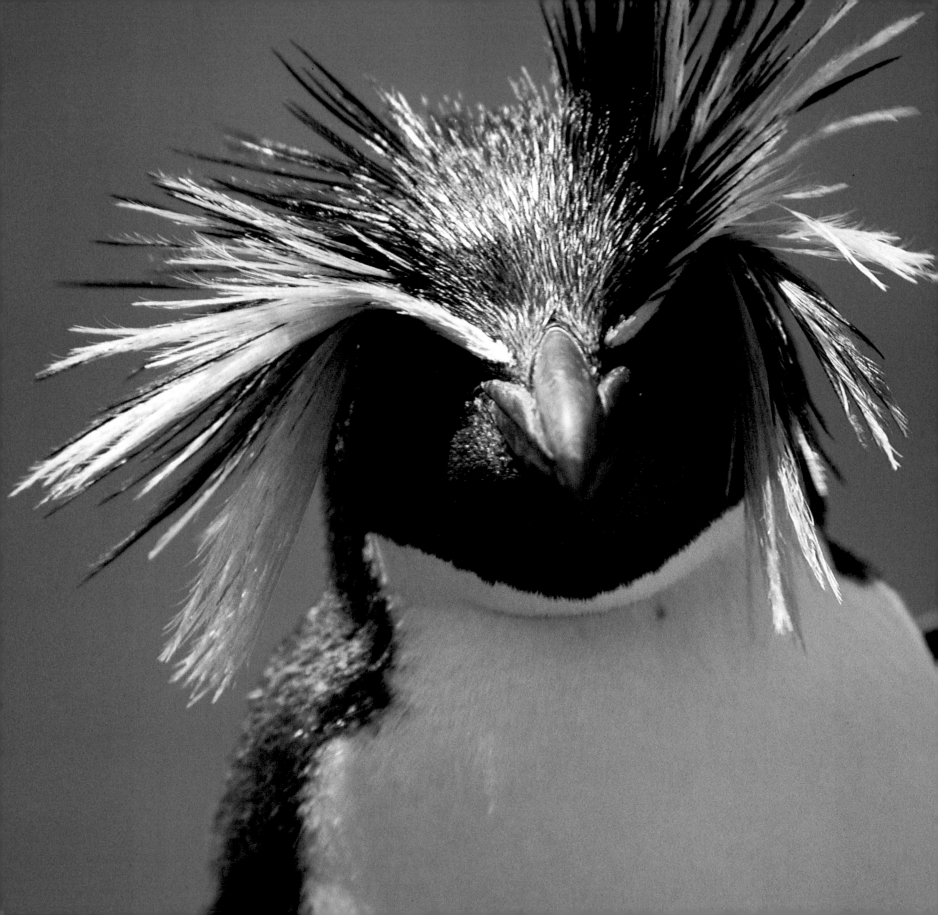

(above) Its waving crown feathers are like tufts of pampas grass.

(left) A rockhopper penguin appears, jumping on the rocks.

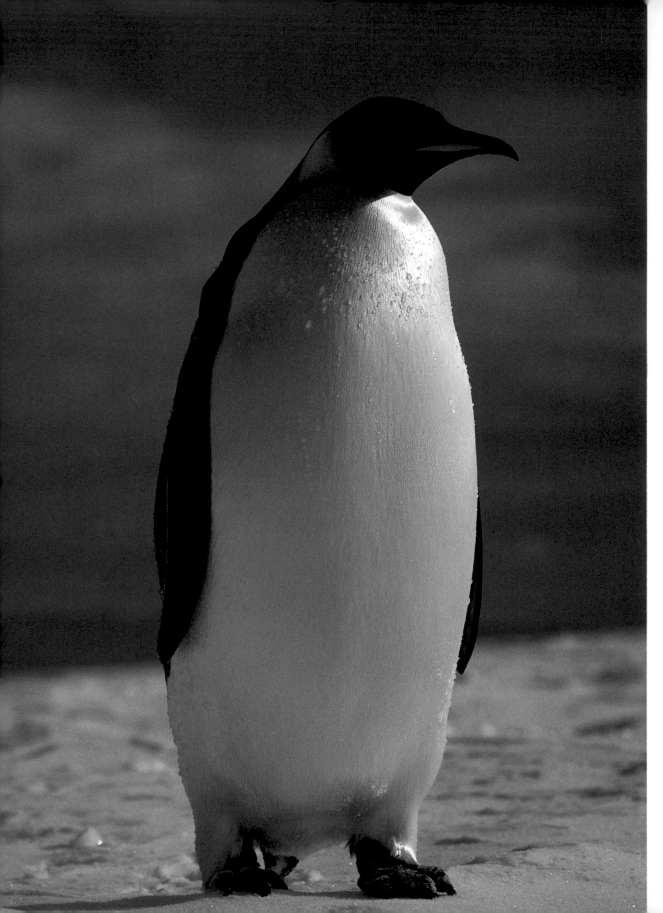

(*left*)

Emperor penguins are the largest of
the eighteen species. They stand about
forty-seven inches high and weigh
about sixty-six pounds.

(*right*)

After two or three wing flaps,
this penguin jumped into the sea.

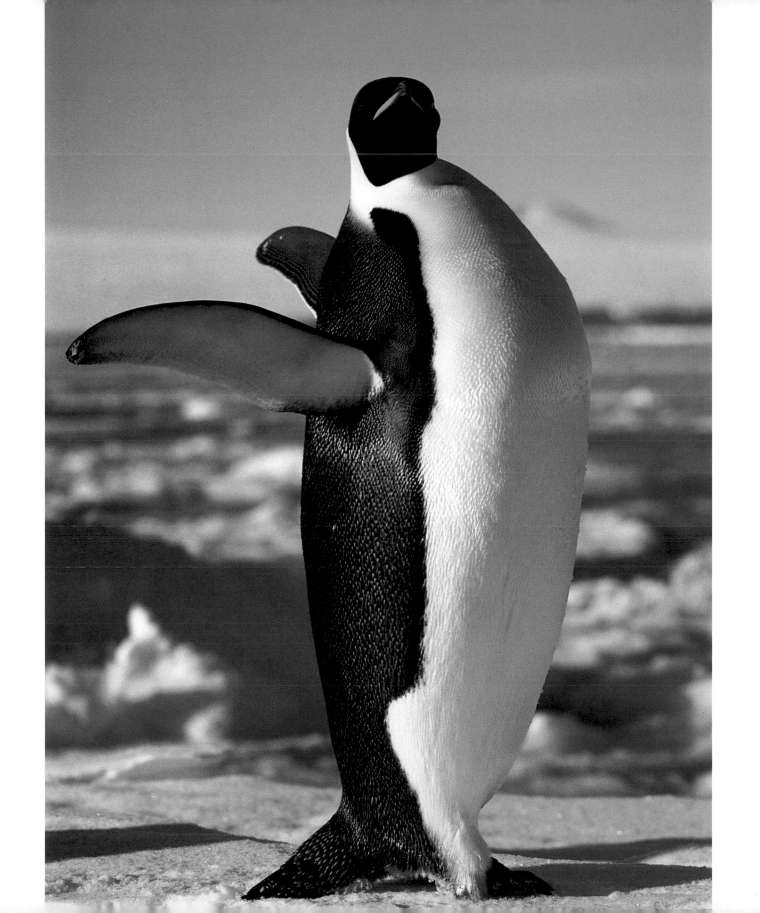

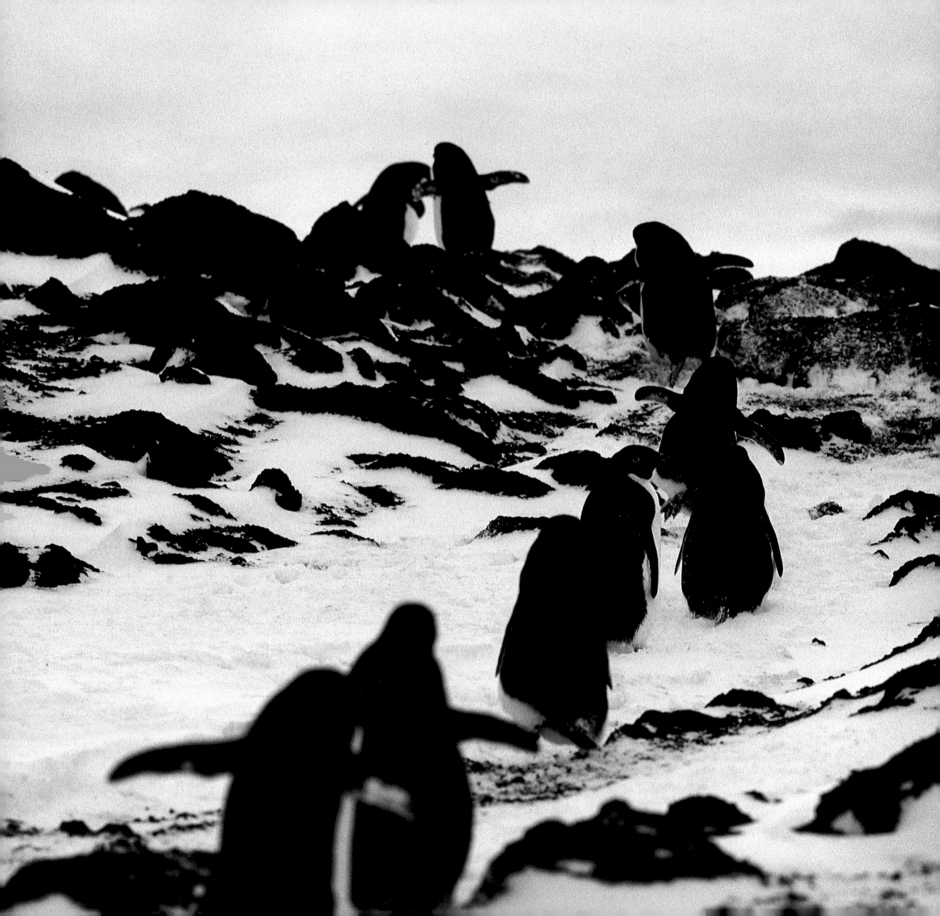

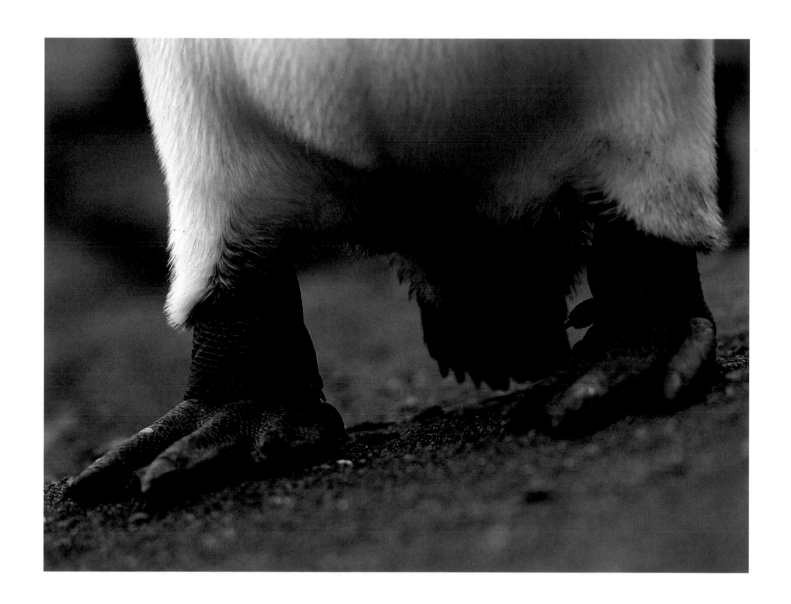

(*above*) **A** king penguin's feet.

(*left*) **B**efore the ocean freezes over, the penguins return to the sea.

91

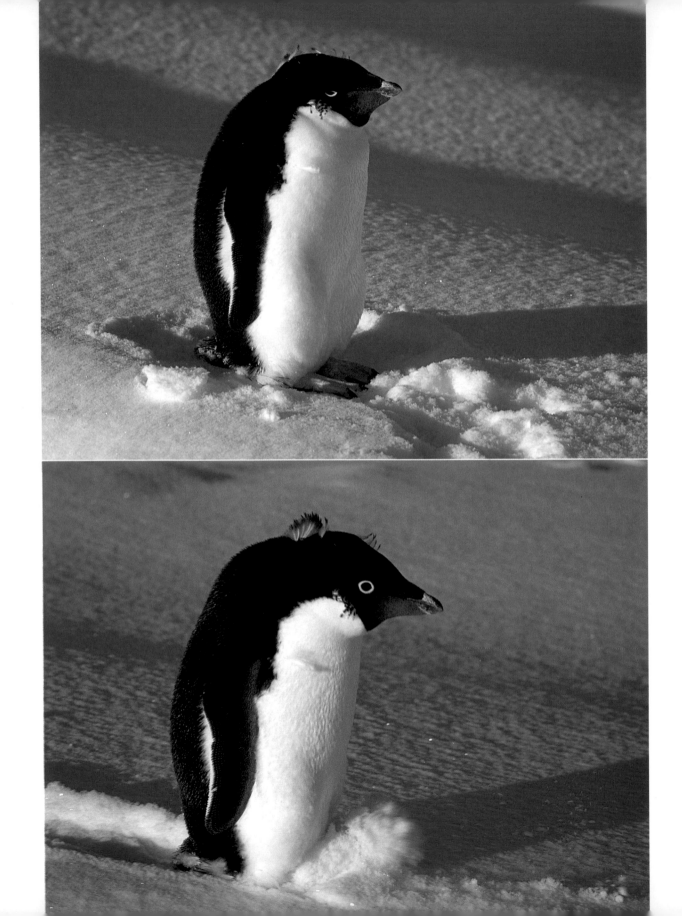

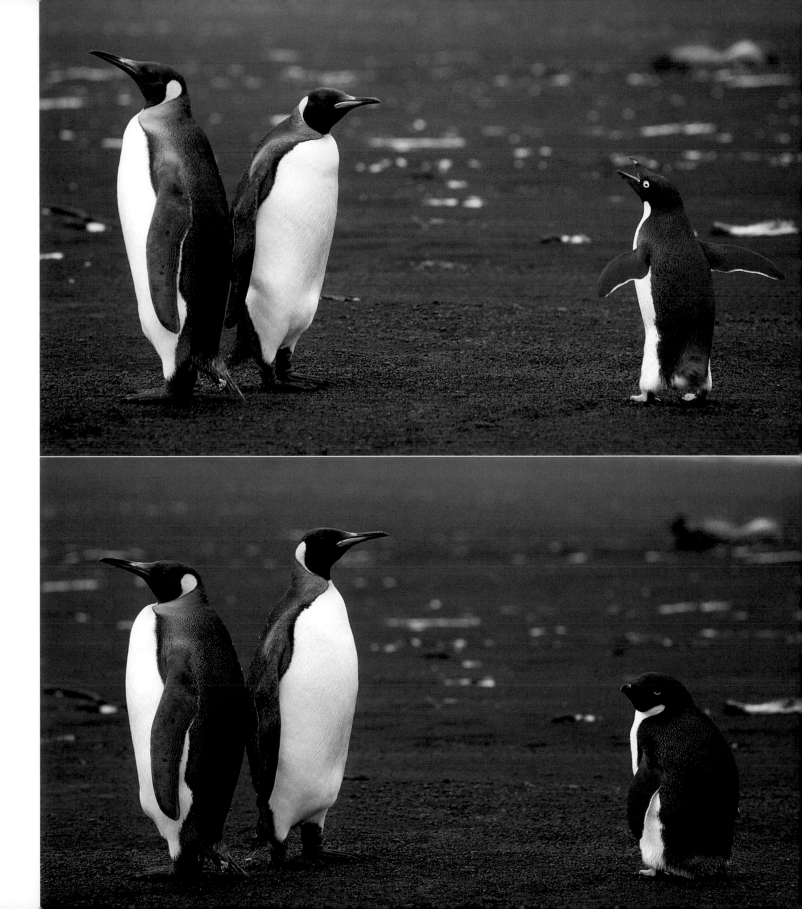

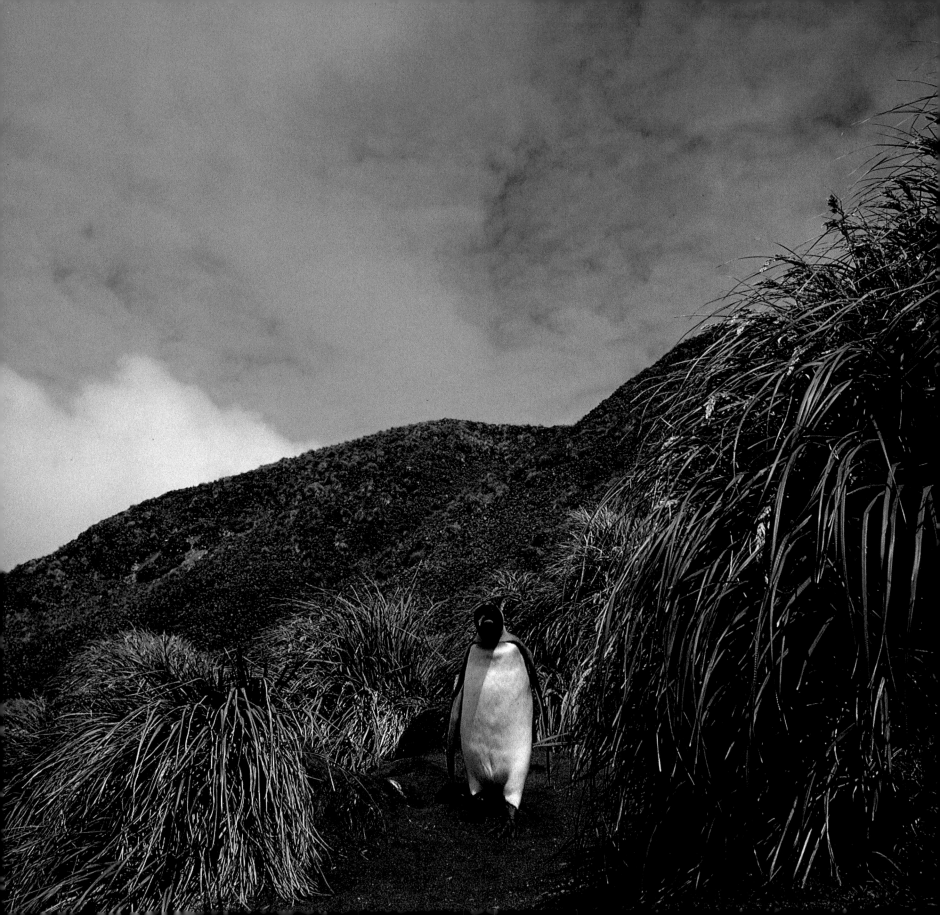

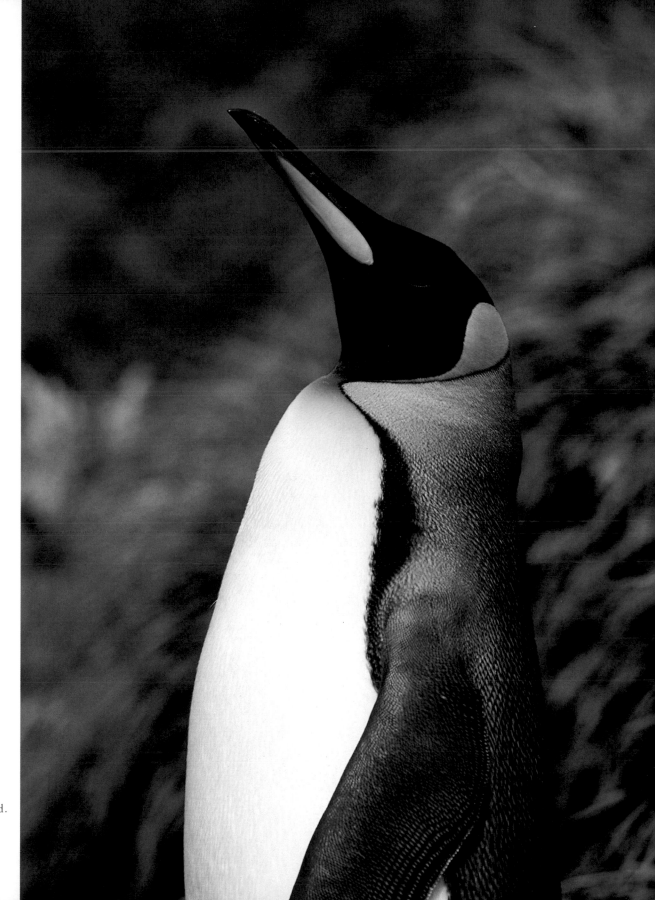

Patrolling the rookery on Macquarie Island.

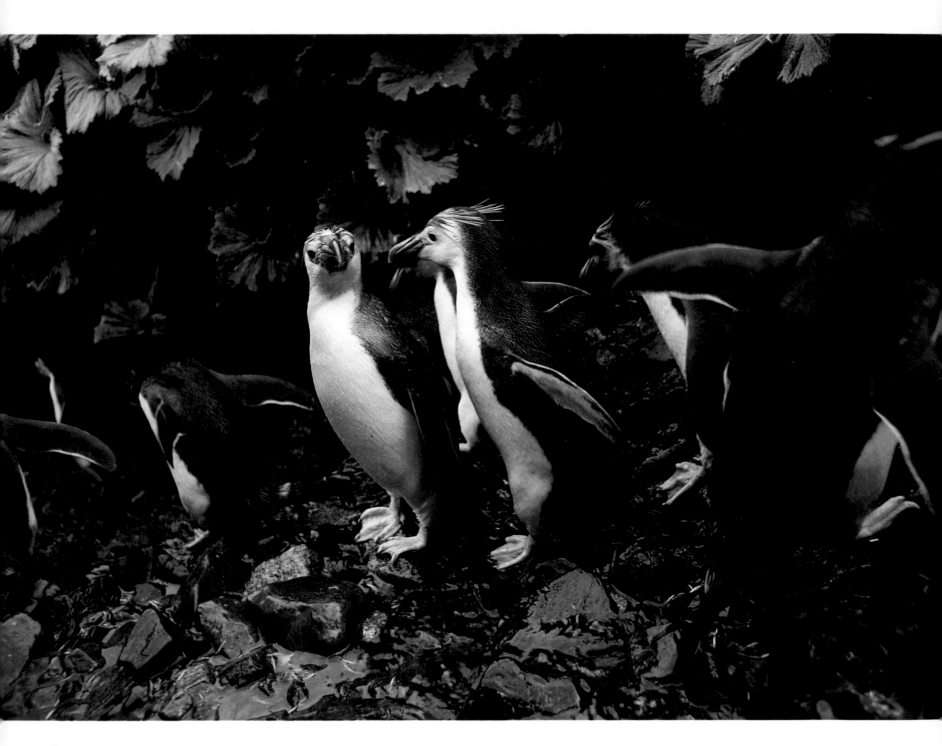

Those on their way to the sea and those on their way to the rookery pass by each other.

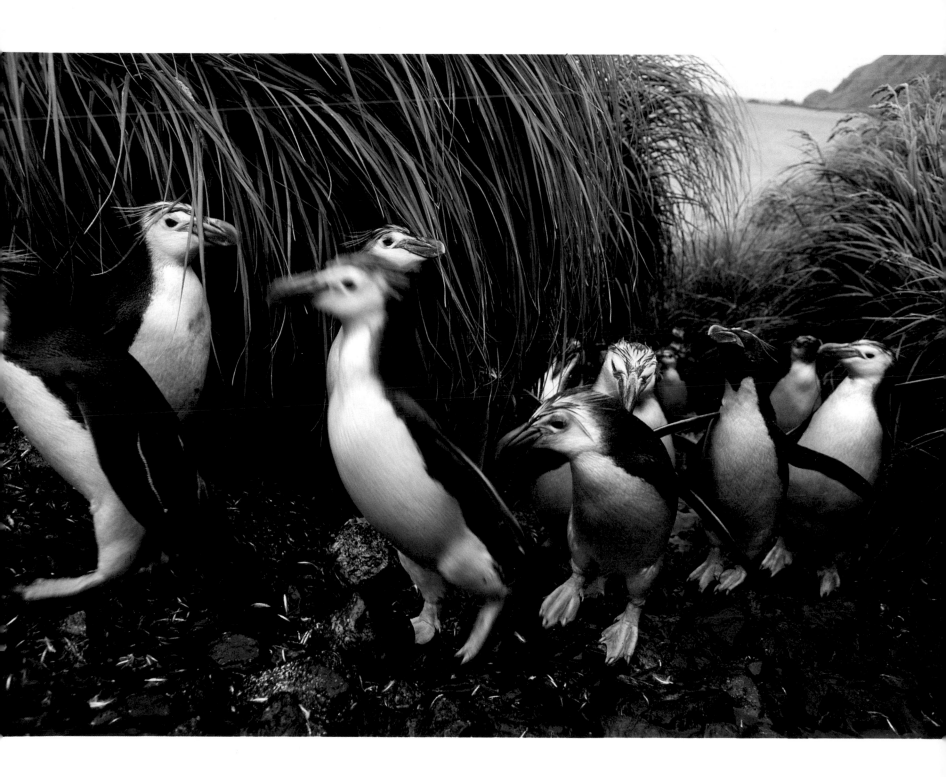

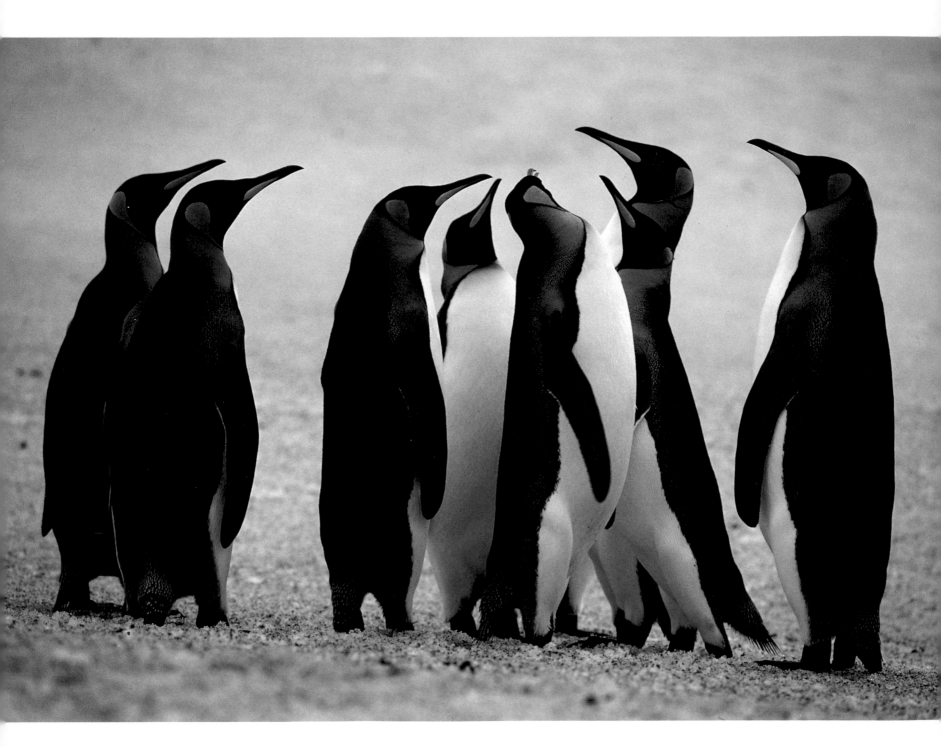

Something seems to have happened. They are striking each other with their wings.

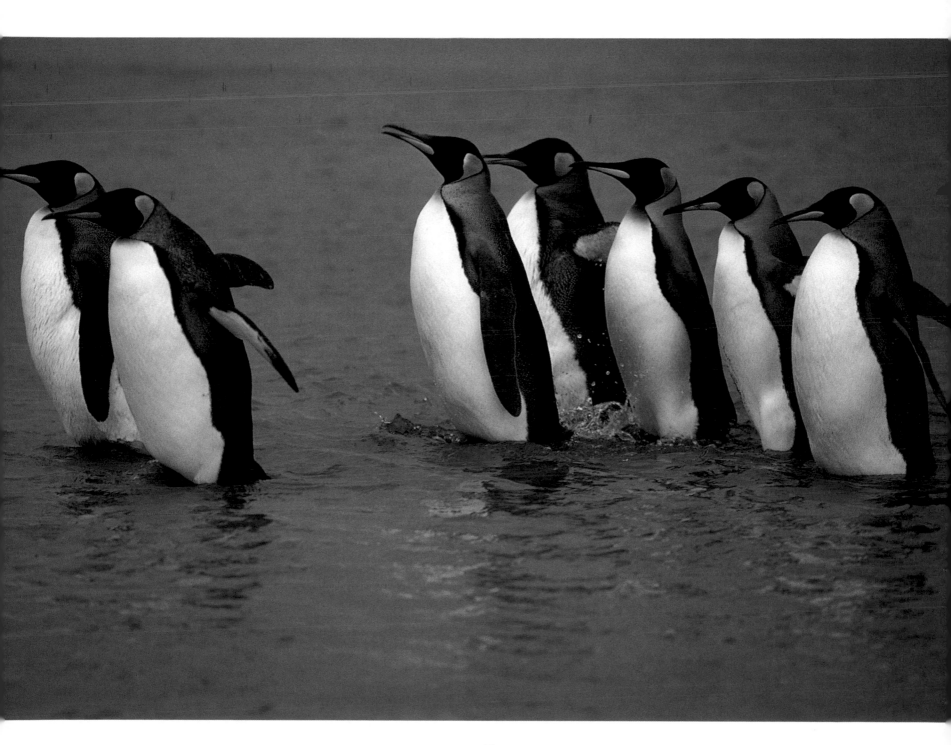

There are no leaders among penguins. One moves, and the others follow.

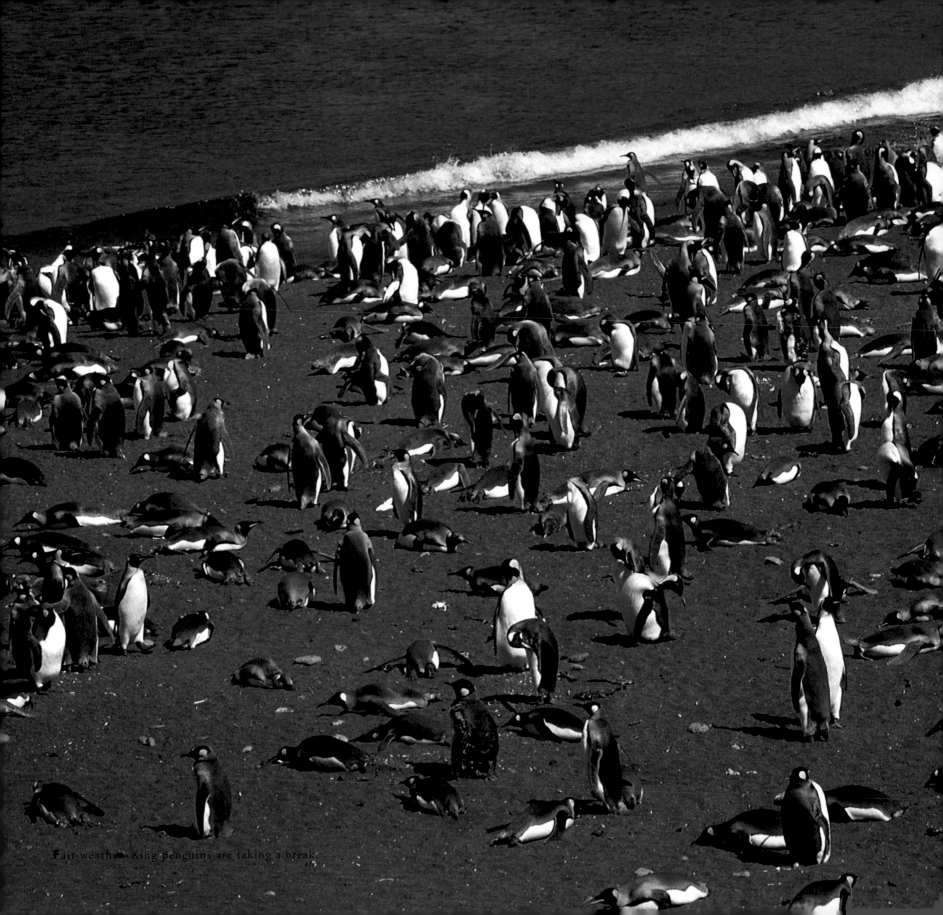

Fair weather: King penguins are taking a break.

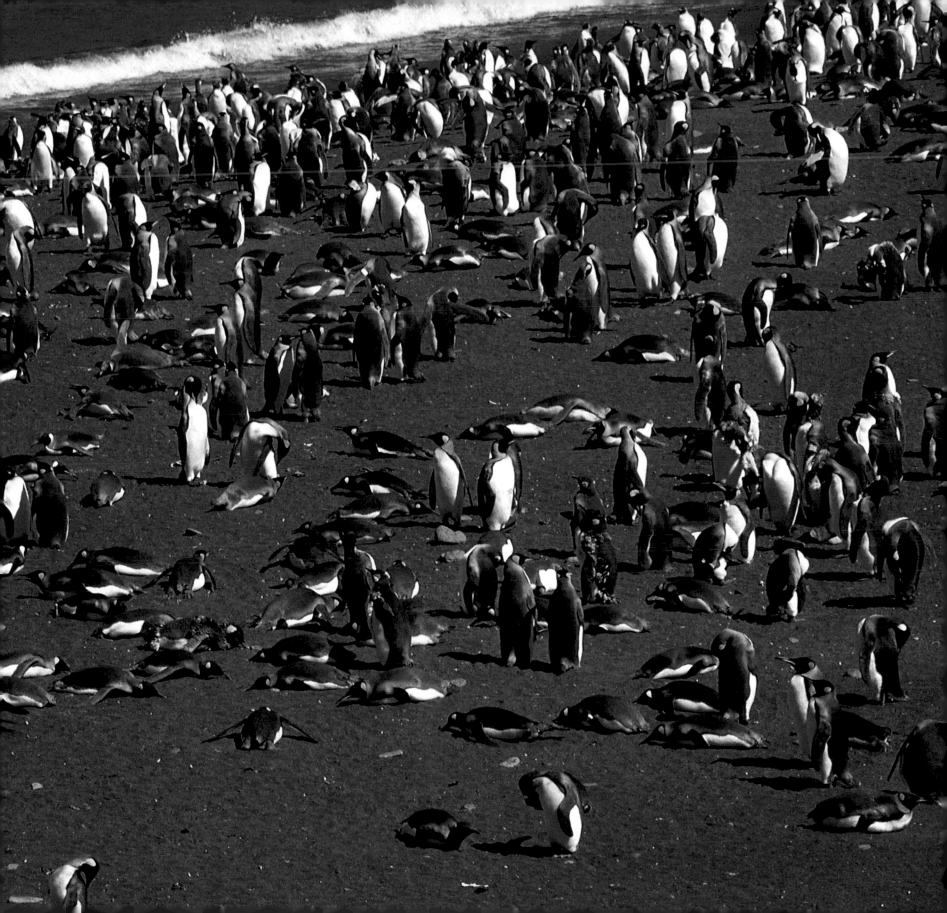

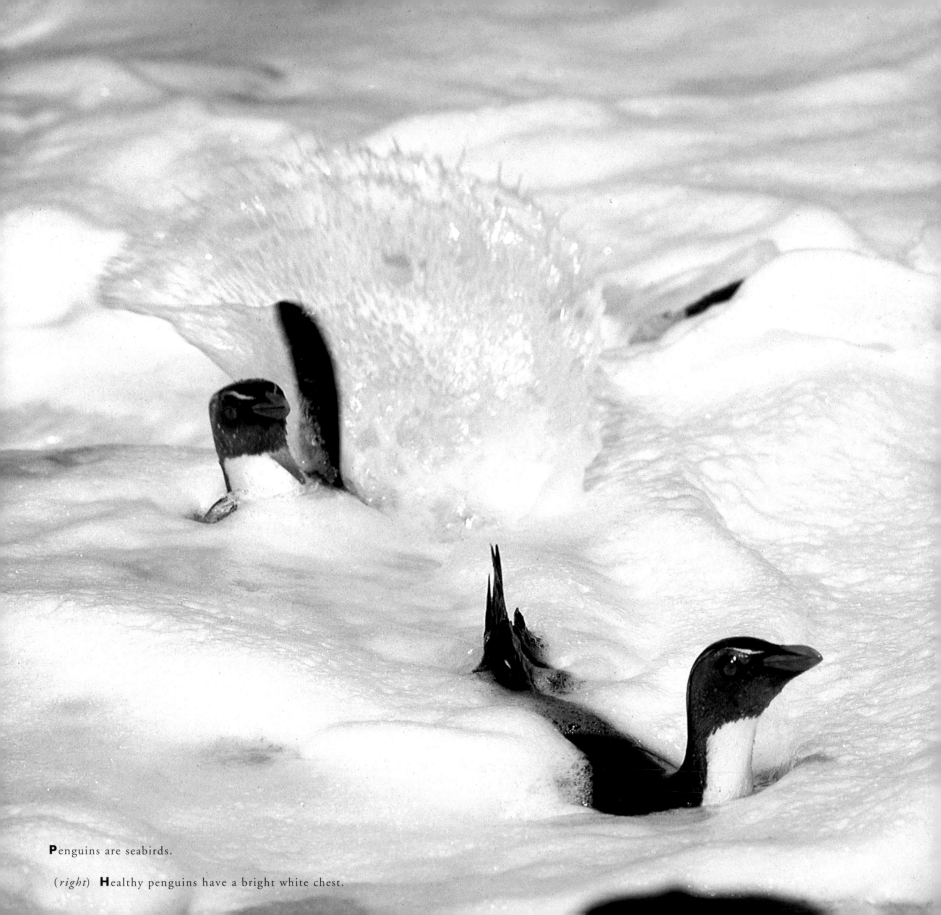

Penguins are seabirds.

(*right*) Healthy penguins have a bright white chest.

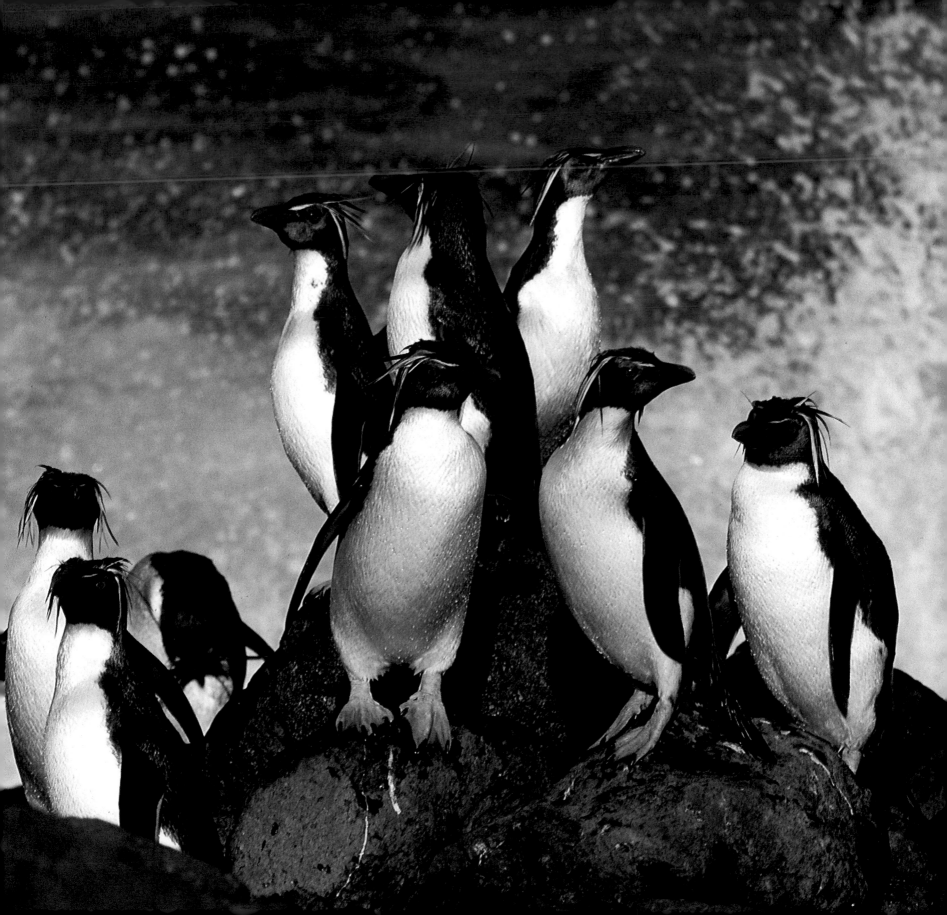

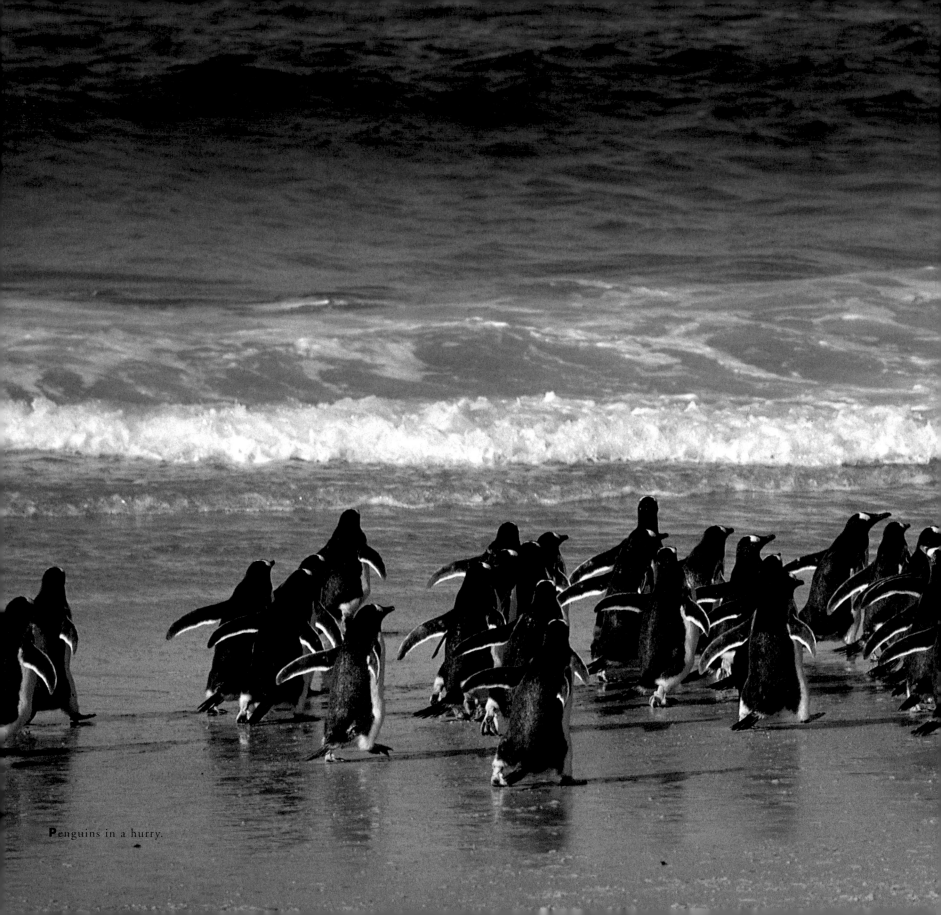

Penguins in a hurry.

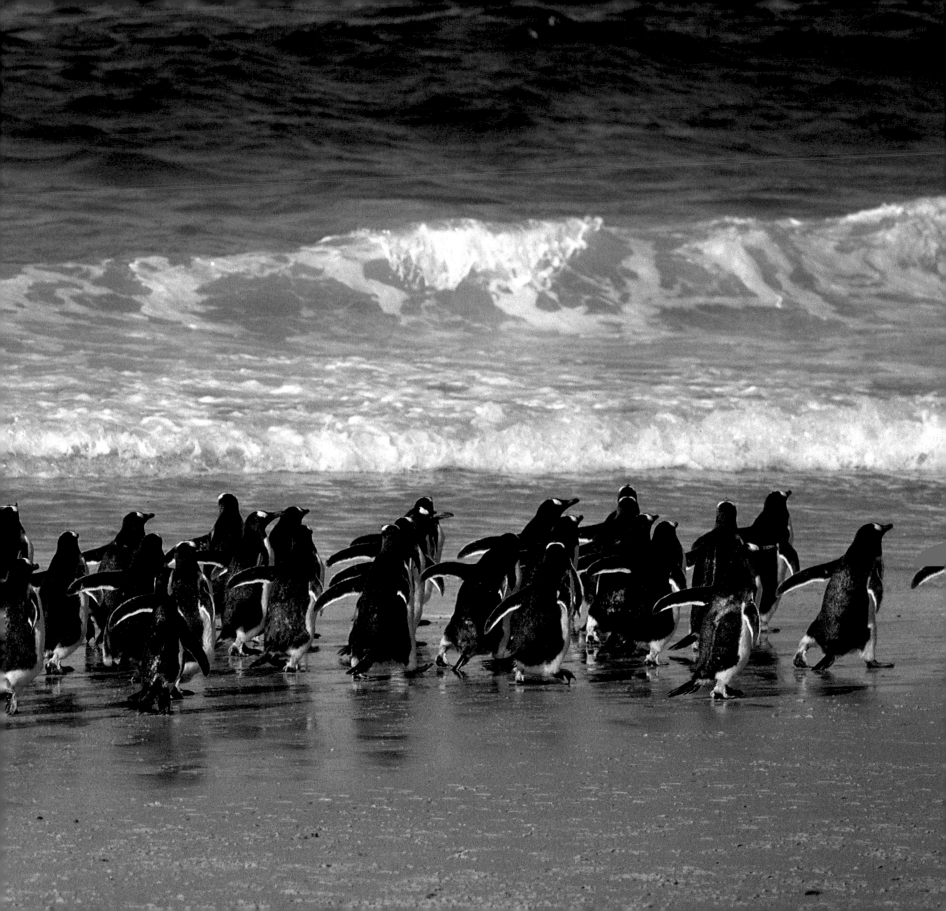

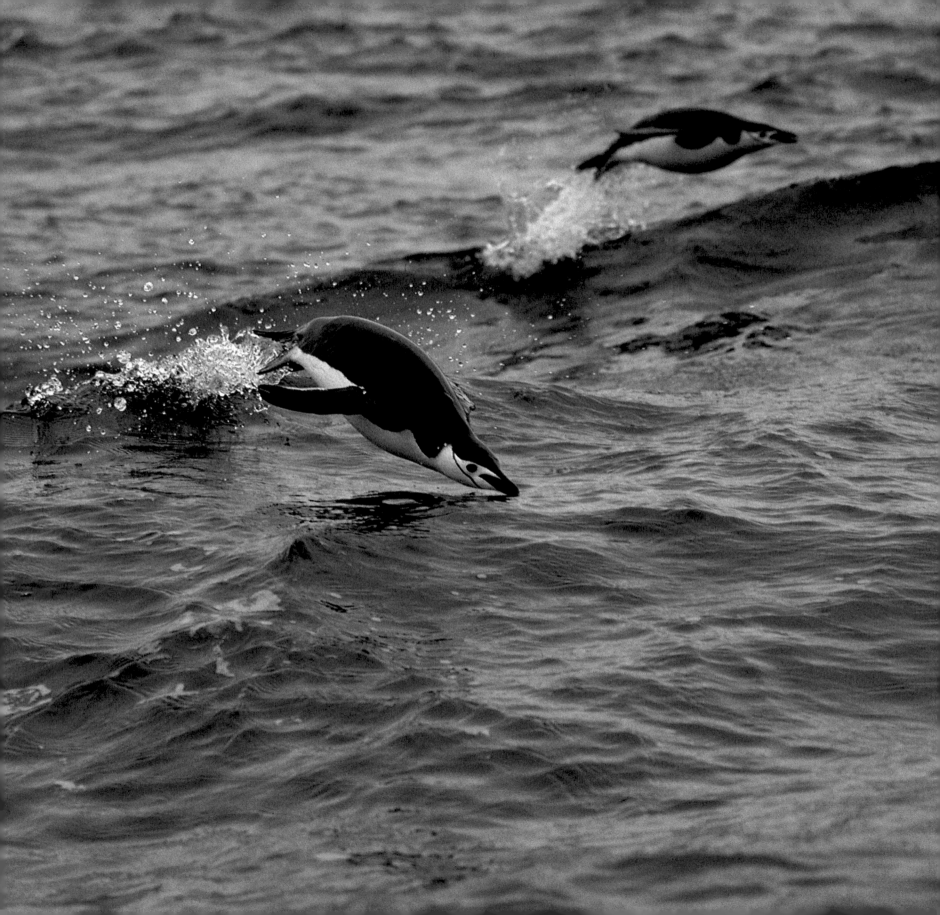

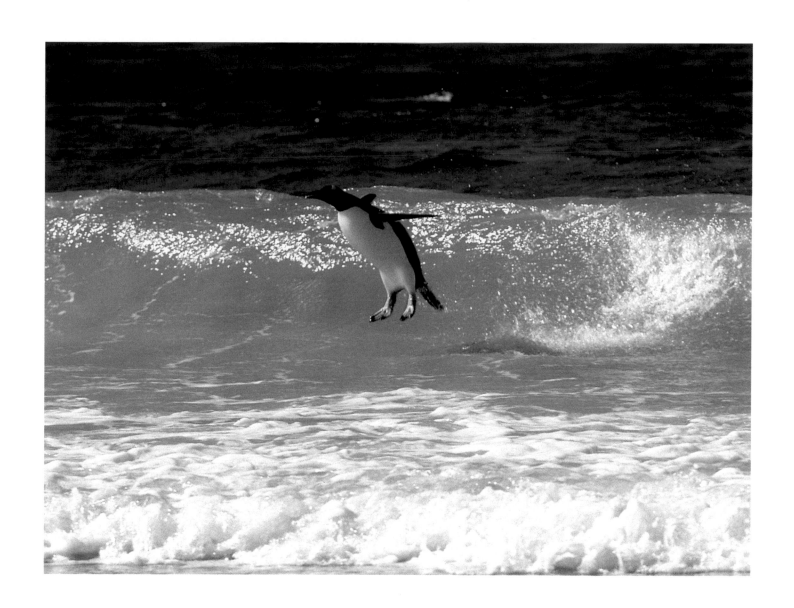

(*above*) **U**sing the springiness of its body, this penguin jumped out through the waves and came to a lovely landing.

(*left*) **P**enguins dolphin-swimming.

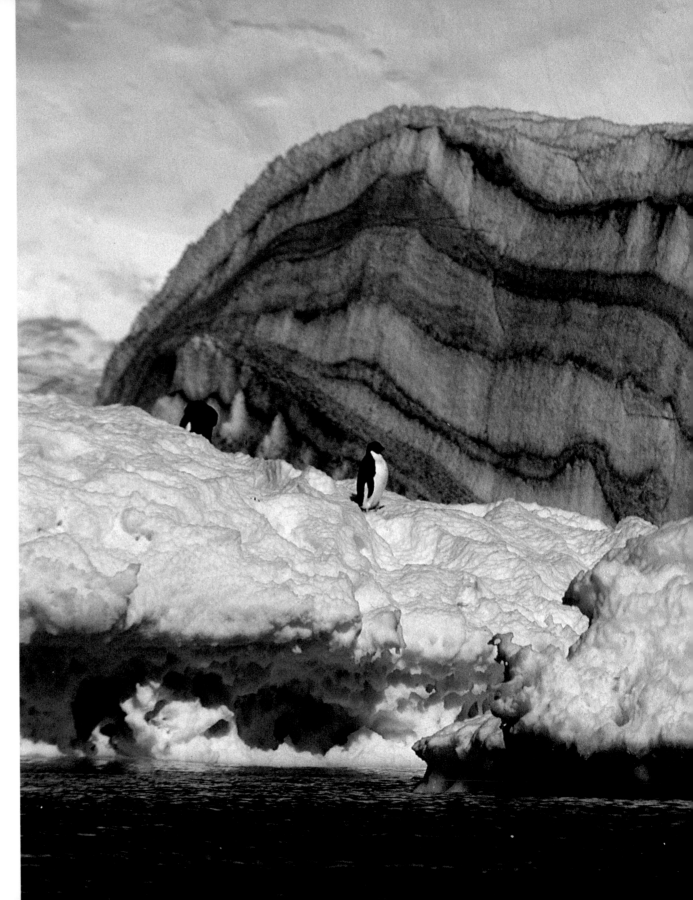

The ice layers of the Antarctic have
been sculpted by a billion years
of history, recording changes in
the earth's climate and crust. For
conditions such as the ozone hole
and increased levels of PCBs,
Antarctic ice is a barometer of
the earth's environment.

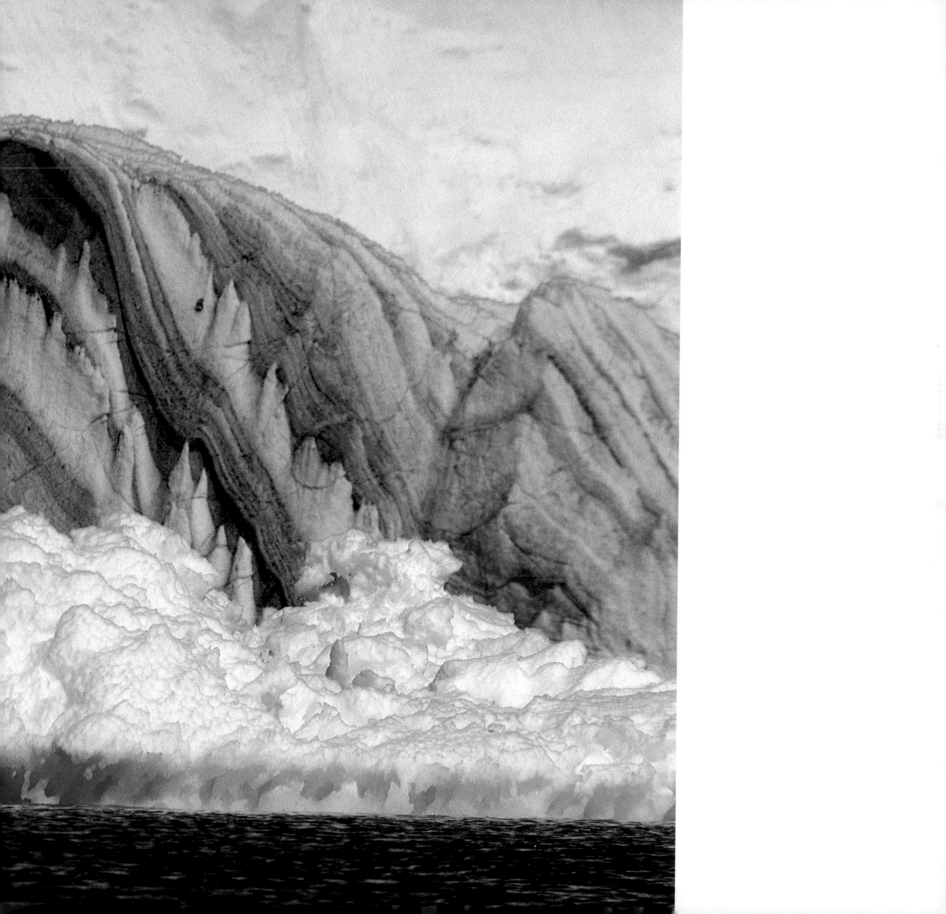

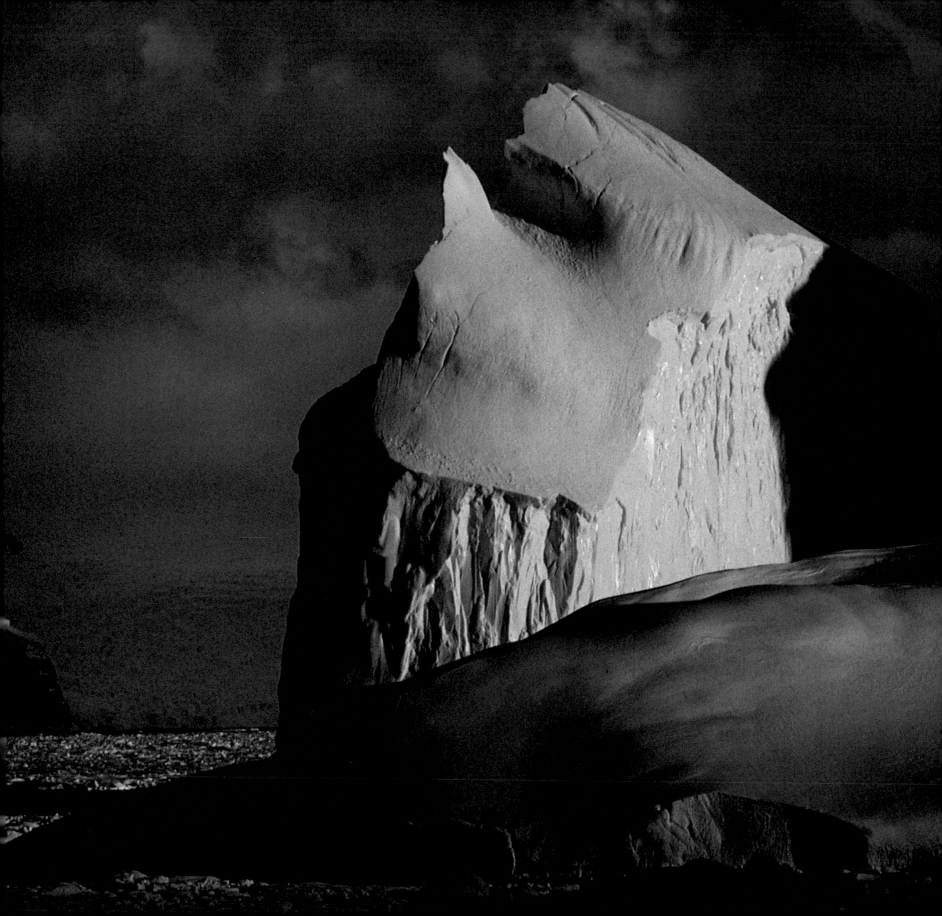

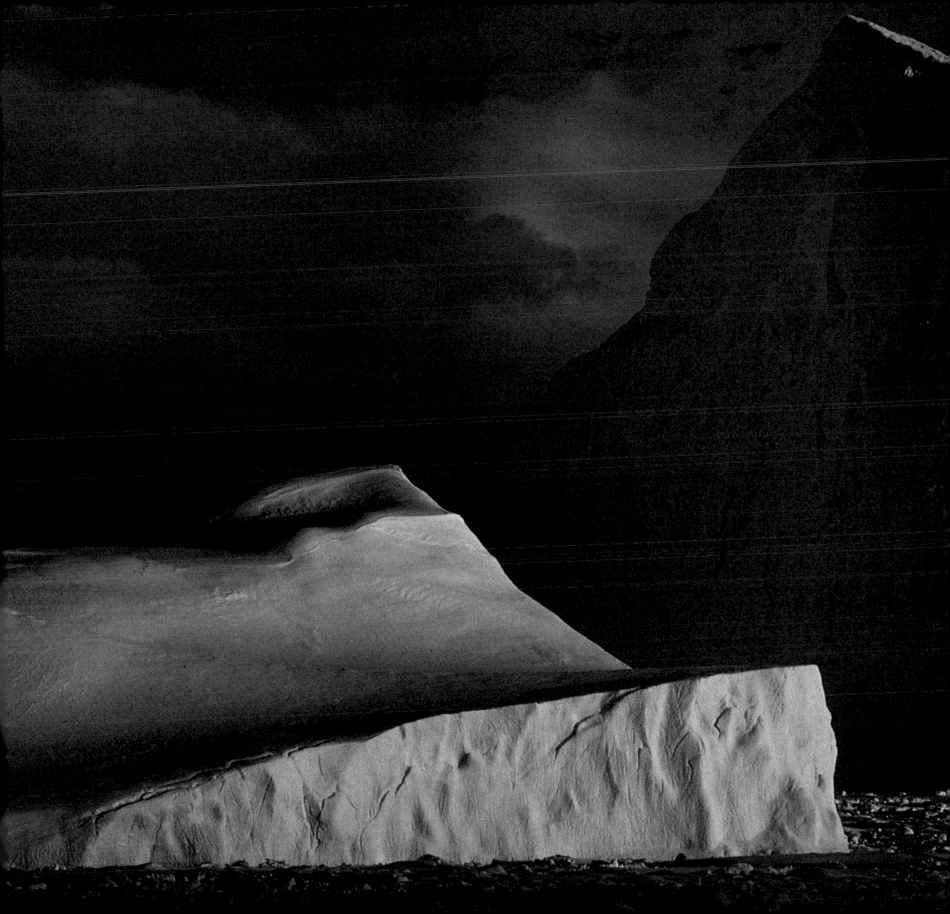

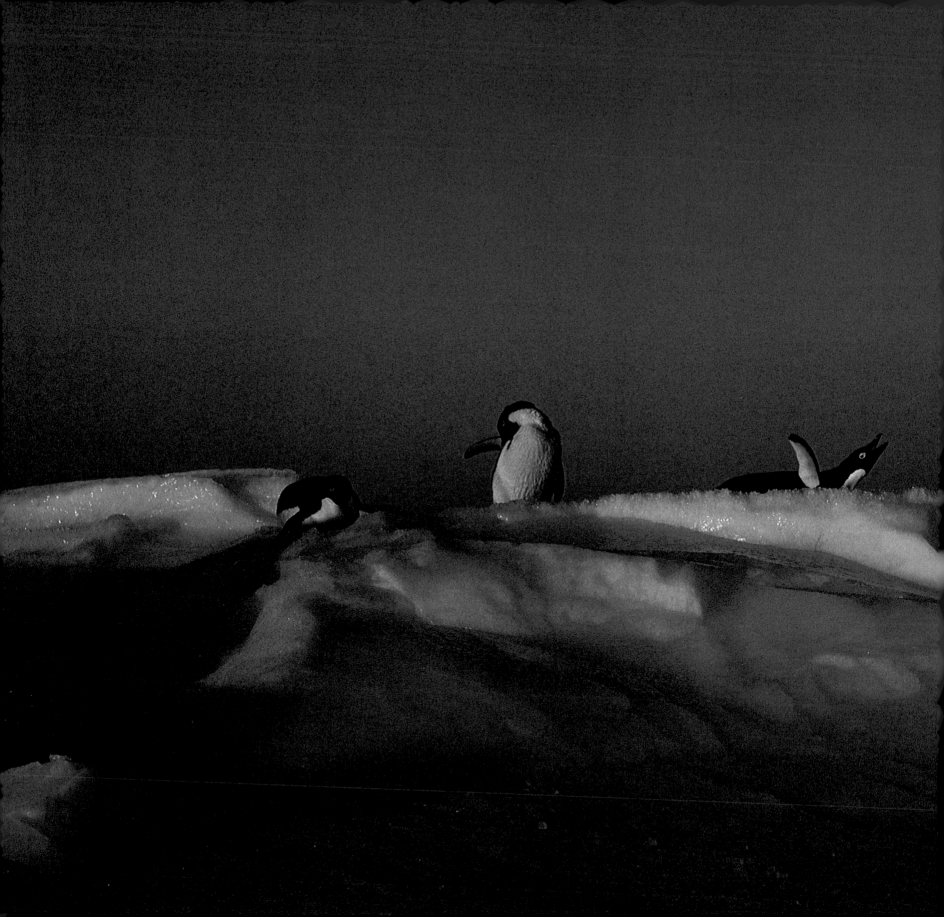

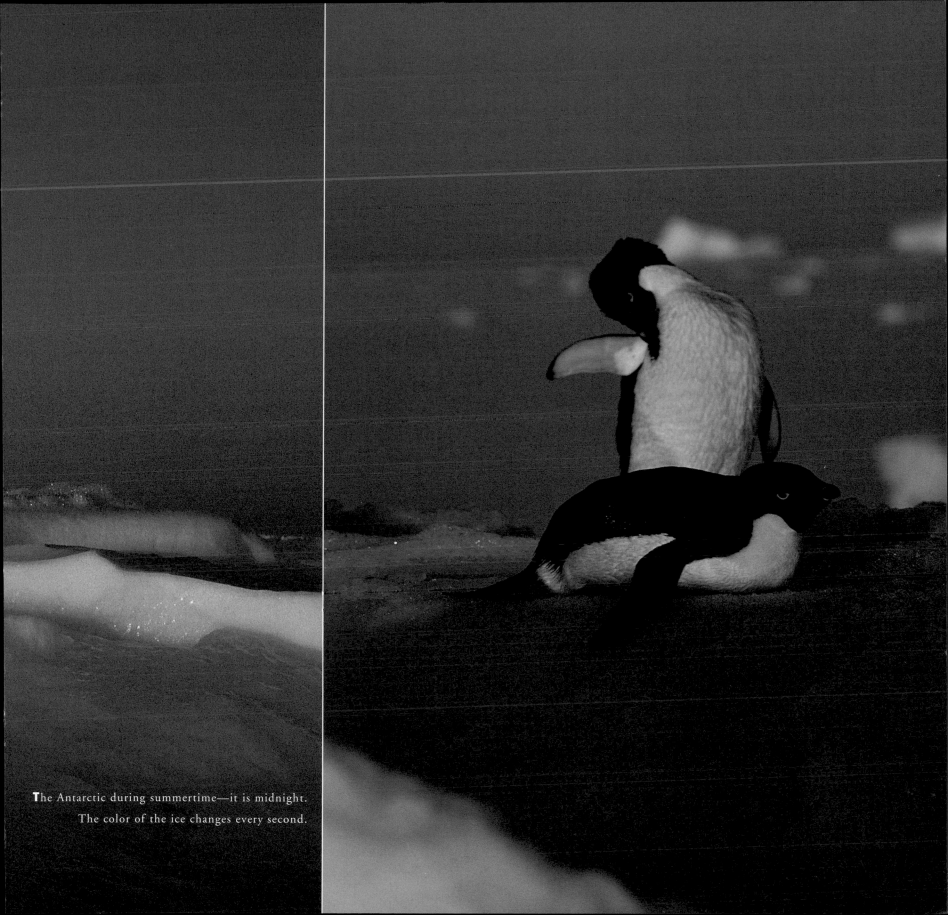

The Antarctic during summertime—it is midnight.
The color of the ice changes every second.

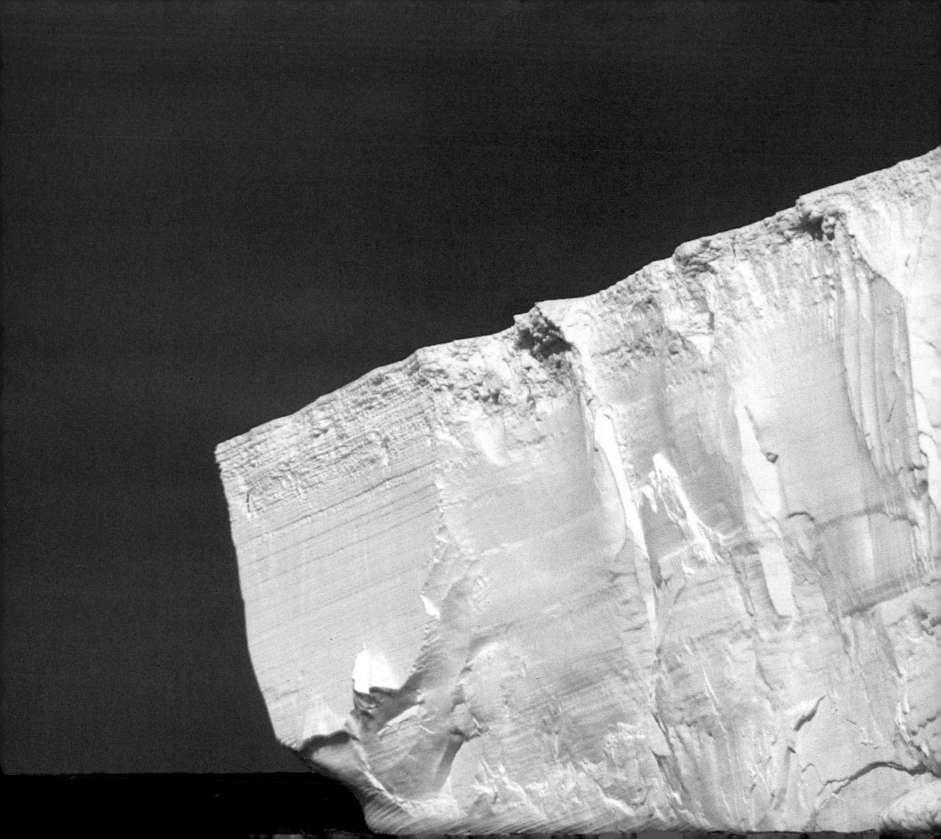

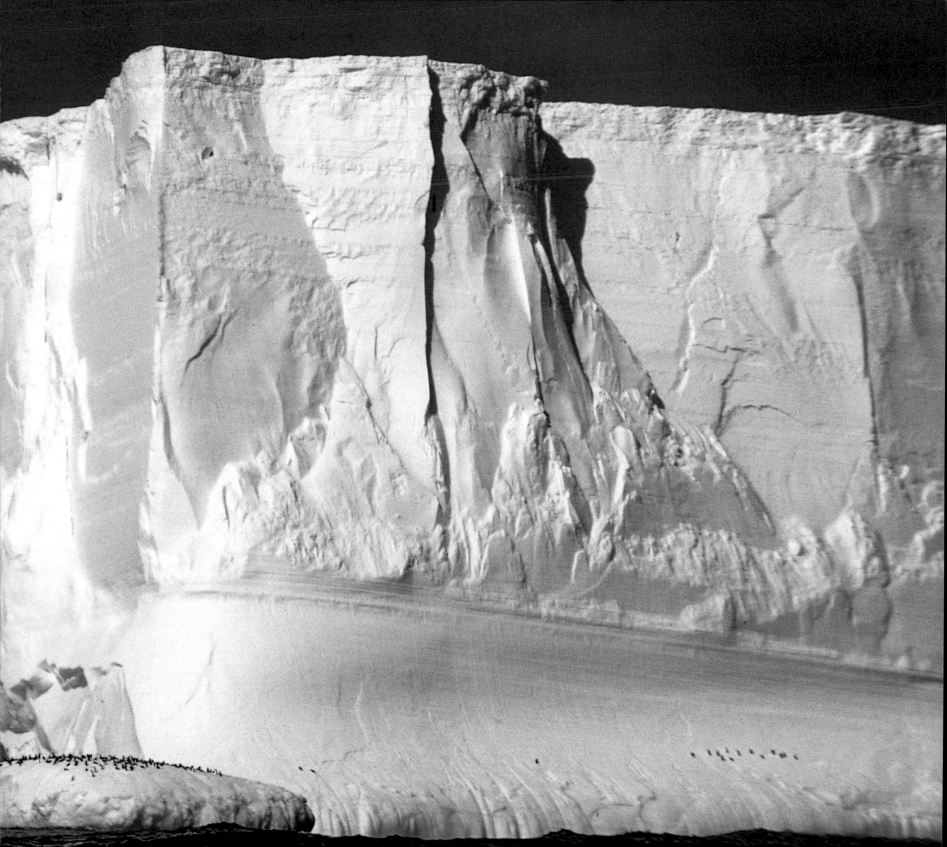

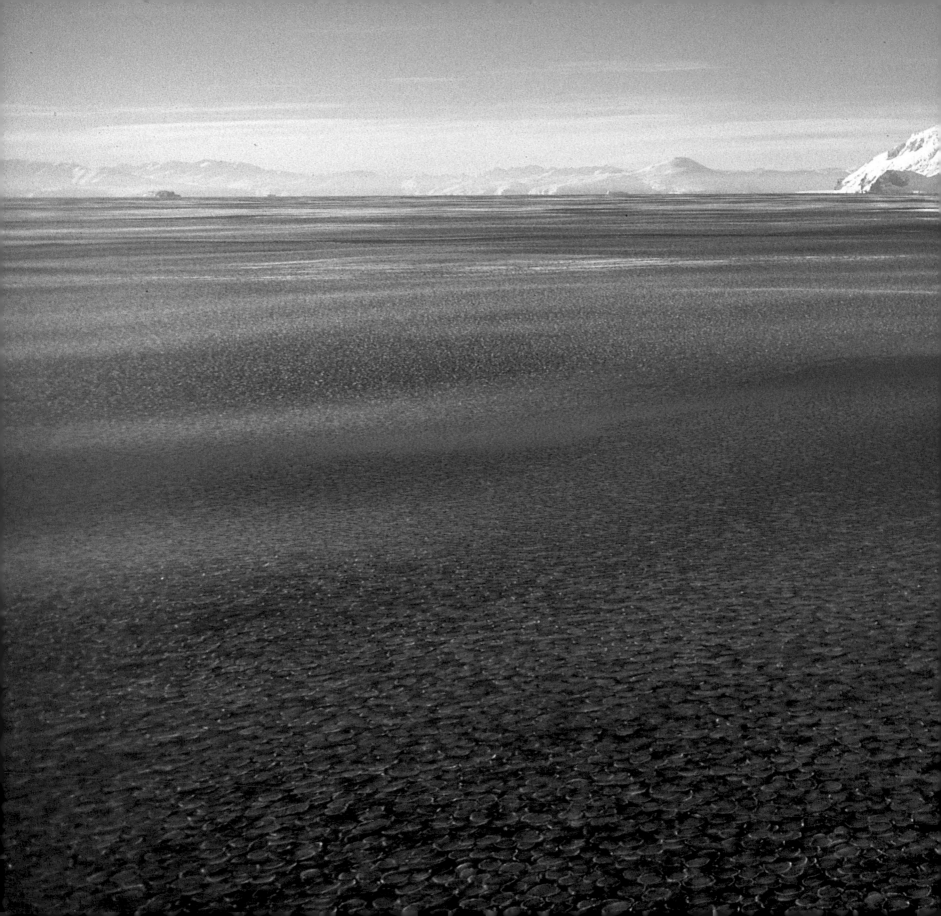

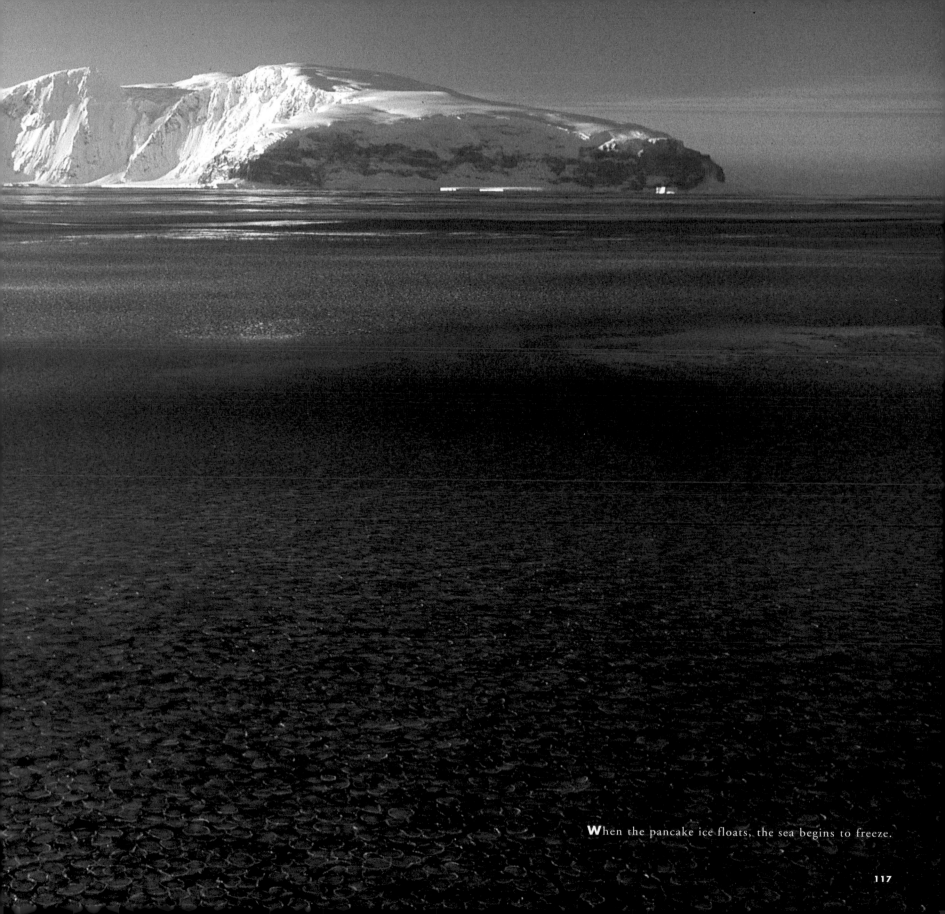

When the pancake ice floats, the sea begins to freeze.

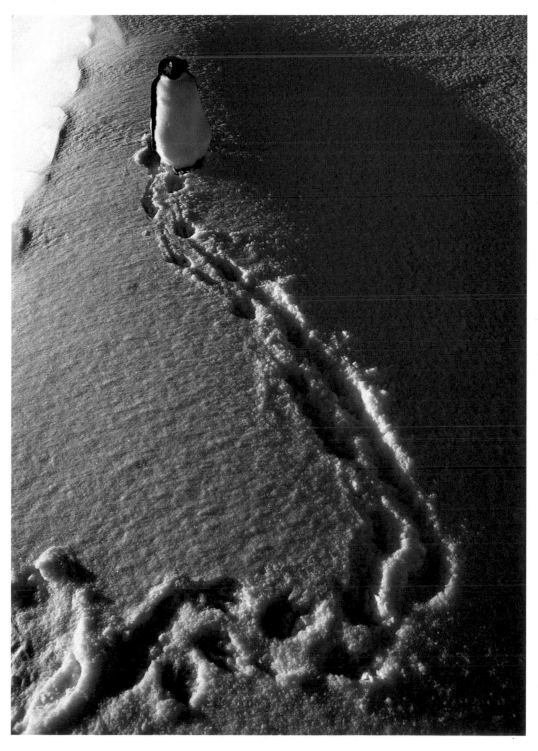

The March sun sets for two to three hours a day. Winter is returning to the Antarctic.

First published in the United States in 1997 by Chronicle Books.

First published in Japan in 1992 by Shogakukan, Inc.

Copyright © 1992 by Mitsuaki Iwago.
All rights reserved. No part of this book may be reproduced
in any form without written permission from the publisher.

Printed in Singapore.

ISBN: 0-8118-1440-8

Library of Congress Cataloging-in-Publication Data available.

Cover and text design: Sarah Bolles
Interior design: Keisuke Konishi
Translation: Michiko Shigaki and Thomas L. J. Daly
Map: Toshiyuki Kimura (Tube)

Distributed in Canada by
Raincoast Books
8680 Cambie Street
Vancouver, B.C. V6P 6M9

10 9 8 7 6 5 4 3 2 1

Chronicle Books
85 Second Street
San Francisco, California 94105

Web Site: www.chronbooks.com